AN UNWEAVING
OF RAINBOWS

Also by John Minihan

SAMUEL BECKETT
with an introduction by Aidan Higgins

SHADOWS FROM THE PALE: Portrait of an Irish Town
with an introduction by Eugene McCabe

AN UNWEAVING OF RAINBOWS

Images of Irish Writers

JOHN MINIHAN

Foreword by Derek Mahon

SOUVENIR PRESS

For Hammond

This book is sponsored by
The Mean Fiddler Organisation

First published 1998 by
Souvenir Press Ltd.,
43 Great Russell Street,
London WC1B 3PA

ISBN 0 285 63458 5

Designed by Motif
Printed in Singapore

Extract of approximately 112 words from 'The Image World' from *On Photography*
by Susan Sontag (Allen Lane 1978) Copyright © Susan Sontag, 1973, 1974, 1977.
Also reproduced by permission of The Wylie Agency (UK) Ltd.
The extract from *The Mangan Inheritance* by Brian Moore is reproduced by permission of
Jonathan Cape and Random House UK Ltd.; McCelland & Stewart, Inc. *The Canadian Publishers*,
and Curtis Brown Ltd., New York. Copyright © 1979 by Brian Moore.
The extract from *The Real Charlotte* by Somerville and Ross is reproduced by permission
of Curtis Brown Ltd., London, on behalf of the Estate of Somerville and Ross.
Copyright the Estate of Somerville and Ross.
The extract from *An Unsociable Socialist* by George Bernard Shaw is reproduced
by permission of The Society of Authors on behalf of the Bernard Shaw Estate.
Quotations from James Joyce's *Ulysses* and *A Portrait of the Artist as a Young Man*
are reproduced with the kind permission of the James Joyce Estate.
The quotation from 'Lines Written on the Grand Canal' by Patrick Kavanagh is reprinted by
permission of Peter Kavanagh from *The Complete Poems of Patrick Kavanagh*, New York, 1996,
edited with commentary by Peter Kavanagh. Copyright © 1972, 1996 Peter Kavanagh.
The extract from 'Ireland's Own, or The Burial of Sir Thomas Moore' by John Betjeman
is reproduced by permission of John Murray (Publishers) Ltd.

THE PARTICIPATING EYE

The illiterates of the future will be the people who know nothing of photography rather than those who are ignorant of the art of writing.
László Moholy-Nagy, *New Vision* (1935)

A photograph, says Susan Sontag (*On Photography*, 1977), is 'not only an image (as a painting is an image), an interpretation of the real; it is also a trace, something directly stenciled off the real, like a footprint or a death mask. While a painting, even one that meets photographic standards of resemblance, is never more than the stating of an interpretation, a photograph is never less than the registering of an emanation.' Photography revives, she suggests, the primitive status of images: 'Our irrepressible feeling that (it) is something magical has a genuine basis. No one takes an easel painting to be in any sense co-substantial with its subject; it only represents or refers. But a photograph is not only like its subject, a homage to the subject. It is part of, an extension of the subject.'

One might argue, of course, that paint, like any material thing, *is* ultimately consubstantial with human bodies; but so too is light, as in the light of the eye. We may speak, in *both* cases, of 'an extension of the subject'; and it's in this sense that John Minihan's systematic record of Irish writers, like John Butler Yeats's graphic work 100 years ago, may be said to contribute to literature itself. Barthes proposes, however, in *Camera Lucida* (1980), that it's not by painting that photography touches art, but by theatre; and he uses the phrase '*tableau vivant*', which is what we have here.

Irish literary photography too (both *of* and *by* the writers) goes back 100 years, though not the full 150; for we had no inspired innovator to capture Mangan, say, as Félix Nadar and others captured Baudelaire — though, in *The Mangan Inheritance* (1979), the novelist Brian Moore tries to rectify this omission by having his protagonist Jamie Mangan, a young journalist, find a fictitious daguerreotype of an ancestor, the poet James Clarence Mangan, in a house in Canada — 'a portrait in a scrolled brass frame preserved under glass, a small, shimmering, mirror-bright picture on silver-coated copperplate. It measured about three inches by four and showed a man facing the camera, a head-and-shoulders portrait taken against a plain background. The man wore a silk cravat, a white shirt, and a dark cape tied loosely about his neck by two broad tapes. His longish hair fell to his shoulders and his slight uncertain smile revealed a missing upper tooth. What made Mangan stare as though transfixed by a vision was that the face in the photograph was his own. He turned the daguerreotype over. On the back of the frame, written in a sloping looped script in the top right-hand corner, was the notation: (*J.M., 1847?*).'

But if there were no Irish commercial photographers to compare with the big European names, there were inspired

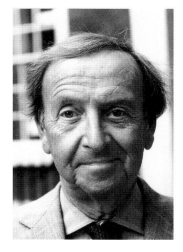

amateurs — some of them writers themselves like Somerville and Ross, Shaw and Synge. The authors of *The Real Charlotte* (1894) bring out the magic, indeed the alchemy of the thing in their description of Christopher Dysart at work in his dark-room: 'There was no sound in the red gloom except the steady trickle of running water and the anxious breathing of the photographer. His long hands moved mysteriously in the crimson light among phials, baths and cases of negatives, while the uncanny smells of various acids and compounds thickened the atmosphere.'

Shaw, writing in 1885, ten years before his own first experiments with the camera, had already decided photography was in some respects superior to art: 'Artists are sticking to the old barbarous, difficult and imperfect processes of etching and portrait painting merely to keep up the value of their monopoly of the required skill. They have left the new, more complexly organized, and more perfect, yet simple and beautiful method of photography in the hands of tradesmen, sneering at it publicly and resorting to its aid surreptitiously. The result is that the tradesmen are becoming better artists than they, and naturally so; for where, as in photography, the drawing counts for nothing, the thought and judgment count for everything.'

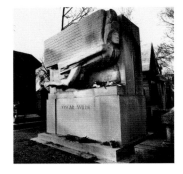

Wilde, who understood the power of the image (think of *Dorian Gray*), was much photographed, notably during his American tour by the New York society portraitist Napoleon Sarony, whose 27 studio shots of the great self-publicist have been frequently reproduced. Wilde sat too for the Julia Cameron studio; and Merlin Holland, in *The Wilde Album* (1997), published for the first time some remarkable late snaps of his grandfather taken in Rome, probably in the spring of 1900, with Wilde's own camera. Wilde himself wrote to a friend: 'My photographs are now so good that in my moments of mental depression I think that I was intended to be a photographer.'

Of the various Irish writer-photographers at the end of the nineteenth century, none achieved more interesting results than Synge, whose 23 surviving studies of life on the Aran Islands were eventually published as *My Wallet of Photographs* (Dolmen 1971), arranged and introduced by Synge's nephew Lilo Stephens. The author of *Riders to the Sea* and *The Playboy of the Western World* used a Lancaster Instagraphic 'plate-and-bellows' camera of polished mahogany in a black leather case with eyeholes for lens and viewfinders, an apparatus now in the library of Trinity College, Dublin.

Joyce was no photographer but was famously photographed at different stages of his life, preferably by the most fashionable practitioners. Portraits of the artist abound — as precocious student, intense young man, *flâneur*, father, convalescent and sage. His striking looks helped, and his dandyism; bow-ties and waistcoats, gym-shoes and walking-sticks contributed to an indelible composite image, and even the tinted specs and

eyepatches he wore to save his failing vision were somehow less functional than decorative. All this and more is evident in Gisèle Freund's late studies done in Paris.

Surprisingly, given his interest in the 'ineluctable modality of the visible', Joyce didn't have much to say about photography as such, except in terms of popular culture: 'The *Bath of the Nymph* over the bed. Given away with the Easter number of *Photo Bits*: splendid masterpiece in art colours . . . Three and six I gave for the frame.' Photo bits, like advertising jingles and music-hall songs, recur throughout *Ulysses*, often with voyeuristic undertones — pictures cut out of papers, those lovely seaside girls ('your head it simply swurls'). Bloom himself is a camera; to Gerty McDowell in the Nausicaa episode he is 'the gentleman opposite looking'. He is even a film camera; for his day, as Joyce describes it, is a home movie of the domestic city. Harry Levin speaks of 'cinematic montage' and 'the optical illusion of reality obtained from a continuity of discrete shots'; and we remember that Joyce was involved (1909) in Dublin's first cinema, the Volta, where too 'projections (tended) to slow down and at times stop altogether, suddenly arresting the action and suspending the characters in mid-air.' Photography as commercial landscape, moreover, is already widespread in Dublin of 1904: 'All kind of places are good for ads.'

Context is established in this new album with formal portraits of literary venues — the Shelbourne (its generational revolving door), Davy Byrne's 'moral pub', Doheny & Nesbitt's, and the old Pearl Bar, once a haunt of journalists. Finn's Hotel is here, where Nora Barnacle worked in youth; the late Hubert Butler's Maidenhall in Co. Kilkenny, a generic portrait of a Georgian country house; and the Protestant church at Farahy, Co. Cork, spiritual home of Elizabeth Bowen. Here too, appendices to Minihan's *Samuel Beckett* (1995),* are the Beckett homes in Kerrymount Avenue, Foxrock, and the Boulevard St-Jacques, where both the 'Cooldrinagh' name-plate and the Paris mail-box have extraordinary presence.

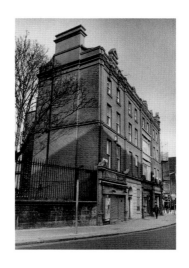

Stephen Joyce, in dark specs like his grandfather, attends the unveiling of a plaque at 28 Campden Grove, Kensington ('Campden Grave', Joyce called it), where James and Nora briefly resided in 1931 in order to be married, 'for testamentary reasons', in England; while Edna O'Brien, with a Molly-esque gesture, smiles in furs from an upstairs window. Ulick O'Connor emerges from the National Library where the young Joyce and his cronies gathered; while the London dimension expands to include three generations of MacNeice women, George Barker and Eddie Linden taking refreshment, and Michael Mannion, the modest 'Bard of Kensington', at work in his bachelor pad, a man-about-town's evening rig airing beside the kettle.

John Ryan and Anthony Cronin are here, veterans of the first commemorative Bloomsday pilgrimage in 1954; but it's a younger crowd who take up most space.

* Secker & Warburg; introduction by Aidan Higgins.

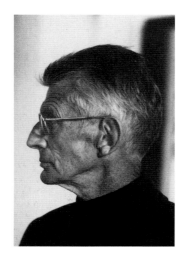

One knows these people, the handsome and the ravaged, the gorgeous and the quaint. A rainbow of personality is unwoven and rewoven here; from all eyes — well, from most — shine soul and sensibility, and these shine back at them from a loving lens.

Unlike *The New Yorker*'s Richard Avedon, whose ultra-cool, harshly lit and decontextualized theatre people Avedon calls 'symbolic of themselves' ('I'm never really implicated; I don't have to have any real knowledge'), Minihan is participatory and idiosyncratic. This is what so distinguished the Beckett book, where the great clinician is obviously in a humorous relation to the camera, so that serendipitous occasions present themselves spontaneously:

the patient cup, the gnarled hands, the walking-away shot from behind.

When we think of great portrait photographers, among the names that spring to mind are those of André Kertész and Bill Brandt — Kertész's Eisenstein, Brandt's Pound and Graves — and Minihan's best work resembles theirs in its warmth and humanism. Working with a Nikon F3, motor drive, a range of lenses from 21mm–200mm, and starting with the Beckett series, John Minihan has established himself as the finest Irish literary portrait photographer of his generation; and the present volume is a vivid extension of the literature it illustrates.

Derek Mahon

Photographs were a rarity in the towns and villages of rural Ireland when I was growing up. Only affluent families had cameras, and when the rest of us wanted to commemorate a special occasion we called in a professional photographer, each family contributing to the cost. Consequently, I never saw photographs at home, and had I remained in Ireland I would probably never have developed an interest in the camera.

Even so, I was still very young when I had my first introduction to photographs. One Sunday I was taken to mass at St Michael's Church in Athy, Co. Kildare, and saw an open prayer book with the place marked by a memorial card. On it was the thumb-sized picture of a loved one. I still remember that muzzy black and white image.

The first time I saw a photograph of myself was in 1953 when, at the age of seven, I made my first Holy Communion. Dressed in a suit with short trousers, I looked so proud standing with my medal outside the church. I can't remember ever seeing a group shot, but the photographer must have taken one.

I was born in Dublin in 1946, but at the age of four months I was taken to live with my uncle and aunt in Athy, and this was my home until I was about eleven years old. Then my relations decided to go and live in London. I remember getting off the mail-boat at Holyhead and hearing the Welsh language spoken for the first time — it sounded totally foreign to my Irish ears. Only when we arrived at Euston Station in

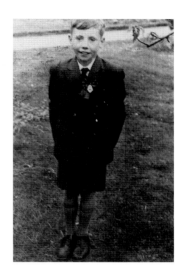

the early morning did it dawn on me that I was starting a new life. My anxieties were mixed with astonishment at the crowds of people and so many shops, more than I had ever seen before. Ireland seemed very far away.

London saw the start of my life as a photographer. When I was fifteen I became an office boy on the London *Evening News*, and the following year I was offered an apprenticeship in the *Daily Mail* darkroom. At that time my job consisted of making up chemicals to develop the hundreds of rolls of film coming from photographers employed all over the country. It was the swinging Sixties, a truly exciting time to be young and especially to be a photographer.

After a few years I began returning home to Athy for holidays, taking my camera with me. I started by taking pictures of family and friends, and gradually it became a mission to document a little of what I remembered from my time as a young lad growing up in Plewman's Terrace — the opening of the Dreamland Dance Hall and how the weekends became something to look forward to, with visiting showbands playing to hundreds of people.

In 1971 I had an exhibition of my Athy photographs at the Royal Court Theatre in London's Sloane Square, to coincide with a season of Irish plays. They were displayed front of house and in the foyer, and when the critic Harold Hobson came to review Brendan Behan's play *Richard's Cork Leg* for the *Sunday Times*, he also looked at my photographs. Afterwards he wrote about

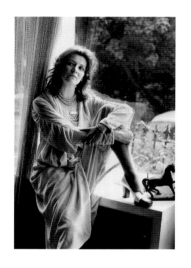

them in his review, calling them 'sad, poignant, despairing and sublime'. Some weeks later the writer Edna O'Brien invited me to afternoon tea at her home in Carlisle Square, Chelsea, where I took photographs of her looking radiant.

I had always been interested in photographing writers. A few years earlier I had photographed the poet W.H. Auden at 'Poetry International' in the Queen Elizabeth Hall on the South Bank. The only reason I had gone there was to take pictures of the Irish poet Austin Clarke, but it was not to be; nor were my attempts to photograph Samuel Beckett when he came to London in 1973 for the double bill of his plays *Not I*, starring Billie Whitelaw, and *Krapp's Last Tape* with Albert Finney, which were put on at the Royal Court.

From that first exhibition in 1971 it became something of a tradition to show my photographs of Athy, and from the early '70s onwards they were being exhibited at various galleries in London and Dublin. They were shown at the Guinness Hopstore in Dublin — an appropriate place because Athy and Guinness have much in common. In the words of the poet Patrick Kavanagh, 'and look, a barge comes bringing from Athy and other far-flung towns, mythologies.' Yes, the barges did come from Athy loaded with malt for Guinness at St James's Gate, Dublin. The Malt House at Athy was among the first to be built by the Grand Canal.

Patrick Kavanagh, who was born in Co. Monaghan in 1904, was very much part of the Dublin literary scene of the '50s and '60s. When he was not holding court in literary bars in Dublin he could be seen sitting on the banks of the Grand Canal watching the swans. He died in Dublin in 1967 and a memorial seat was erected by his friends, overlooking the canal.

The more obsessive I became about photographing my home town, the more literary connections I discovered. James Joyce makes reference to Athy in *A Portrait of the Artist as a Young Man*: '—Can you answer me this one? Why is the county of Kildare like the leg of a fellow's breeches?

Stephen thought what could be the answer and then said:
— I give it up.
— Because there is a thigh in it, he said. Do you see the joke?'

Whenever I exhibited my photographs I wanted my friend Michael Mannion, known as the Bard of Kensington, to open the show with a poem from W.B. Yeats or Oscar Wilde. Michael had a wonderful memory and could recite a poem at the drop of a hat. He died in 1986 and is buried in Galway.

In 1980 Samuel Beckett was in London to direct his play *Endgame* at the Riverside Studios in Hammersmith. He was staying at the Hyde Park Hotel in Knightsbridge, and I decided that I would again try to photograph him. I wrote to him, explaining that I was an Irish photographer and had been photographing Athy for nearly twenty years, including a sequence of pictures, taken over three days and two nights, on the wake of Katy Tyrrell. I left

the letter at the hotel and telephoned the following day. On giving my name I was put straight through to Beckett's room. A soft Dublin voice thanked me for my letter and said that he would like to see my Athy photographs. He would see me the next morning and I could bring my cameras.

As I watched him looking through the photographs, I thought how fortunate I was to be in the same room as this intensely private man. It was a small room at the back of the hotel, with a view of Hyde Park. On the bedside table was a well-thumbed copy of *Endgame*. Beckett seemed to take a long time looking at the pictures, occasionally asking the name of one of the people. It is not generally known that Samuel Beckett once wrote for the camera — a short 35mm black and white piece called *Film*, with no dialogue, which featured the silent movie star Buster Keaton. It was filmed on the streets of New York in 1964, the only time that Beckett went to America.

He allowed me to photograph him while he was in London, and invited me to rehearsals at the Riverside Studios. Trying to take pictures of him was difficult, for he tended to stand in the dark auditorium watching the actors rehearse in very low light, giving his approval with a nod or a smile. I was to photograph him again in London in 1984, and in Paris in 1985, when I took a new portrait for his eightieth birthday celebrations the following year. Later I would show my photographs of him at galleries and at theatres where his plays were being performed.

It became my idea of a family holiday to attend literary festivals which are popular and well established in both Ireland and England. There I would photograph the writers. Back in the early '70s I had photographed the poet John Betjeman and listened to him reciting a poem about the Irish poet Thomas Moore, who was born in Dublin in 1779 and is buried at St Nicholas' Church, Bromham, in Wiltshire:

> I can but regard you neglected and poor,
> Dead Bard of my childhood, mellifluous Moore,
> That far from the land which of all you loved best,
> In a village of England your bones should have rest.

I had to find the grave of Thomas Moore, who died in 1852 and lived with his wife Bessie in Sloperton Cottage, Bromham, for more than thirty years. A Celtic cross marks his grave, with an inscription by his friend Lord Byron: 'The poet of all circles and idol of his own'.

I went on to seek out and photograph the graves of other writers. Graveyards have always fascinated me, especially the one at the monastery of Clonmacnois on the Offaly bank of the River Shannon; its tombstones are possibly the best examples of early Christian influence anywhere in the world. Clonmacnois was founded by St Ciarán in about AD 548, and I have included it in this book because the monastery was a place of learning, a landmark for culture.

On 10 August, 1994, the widow of Dylan

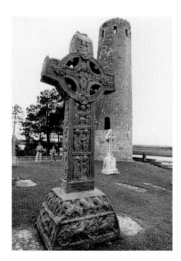

Thomas, Caitlin, *née* Macnamara, went 'gentle into that good night'. Her family came from Ennistymon, Co. Clare, and I first met her in London in the early 1970s when she came from her home in Sicily to launch a book about her life with Thomas. She was a passionate woman and proud of her Irish roots. I attended her funeral at St Martin's Church, Laugharne, near Carmarthen, where she was buried beside her husband who died in New York in 1953. A simple wooden cross marks their grave.

It took me some time to find the grave of the playwright John Millington Synge who is buried in Mount Jerome Cemetery, Dublin. In the end I had to ask the gateman, who inquired when he died. I told him 1909. 'Jesus, I've only been here two weeks!' was the reply in a strong Dublin accent.

Plaques in honour of dead writers have their place in this book, too. I was present at the Theatre Royal, Haymarket, in 1995 when Sir John Gielgud with Merlin Holland, Oscar Wilde's grandson, unveiled a plaque in honour of Wilde.

I am a compulsive portrait photographer who works in a documentary way, trying to tell a story with pictures. This can only be done over a long period, with a strong belief in the subject. Perhaps one of my most pleasing encounters was in 1984, when I met the Belfast poet Padraic Fiacc. It was Brian Keenan who suggested that I should photograph him, promising to arrange a meeting at the Crown Bar the following day. Little did I know how significant the picture I took of Keenan and Fiacc would prove to be: just a couple of years later, Keenan was kidnapped by the fundamentalist Shi-ite militiamen and held captive for nearly five years. I arranged for Padraic Fiacc to come to London for poetry readings and my picture of him with Keenan was published in the national press to keep Keenan's memory alive.

The oral tradition in Ireland has been well documented, but photography in the lives of Irish writers has not been explored. No one photographer can claim that his vision has altered our image of the world, but we have all used our own personal ways of seeing to preserve our traditions, viewed according to where we come from. When I see a photograph of W.B. Yeats at Coole Park, Co. Galway, the home of Lady Gregory, I look to see if it was taken by George Bernard Shaw or John Millington Synge who often had their cameras with them when they went to visit Lady Gregory. Today, all that is left to remind us of those days at Coole is a copper beech tree carved with the initials of the most famous writers of the time.

It used to be said that the camera cannot lie, but with image-manipulation technology it is now possible to alter people's expressions, change grey days to sunny days. As for me, I am still of the old school, whose photographs are irrefutable proof that something happened.

John Minihan

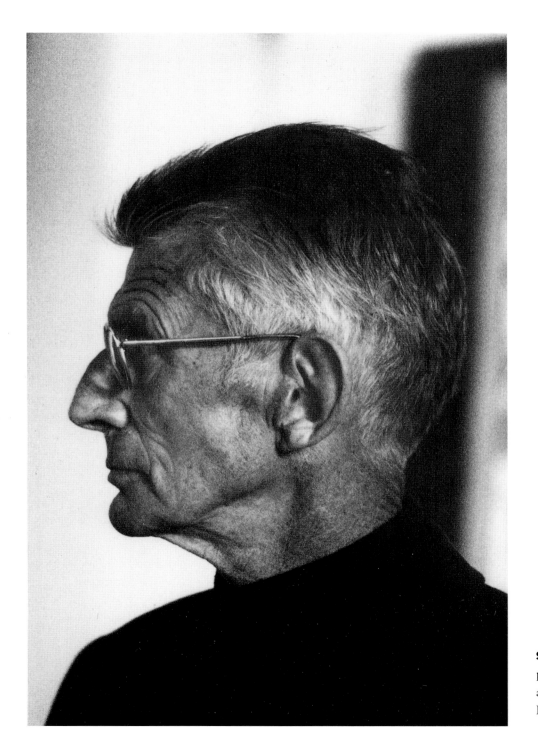

Samuel Beckett, playwright, novelist and Nobel Prizewinner, London 1980.

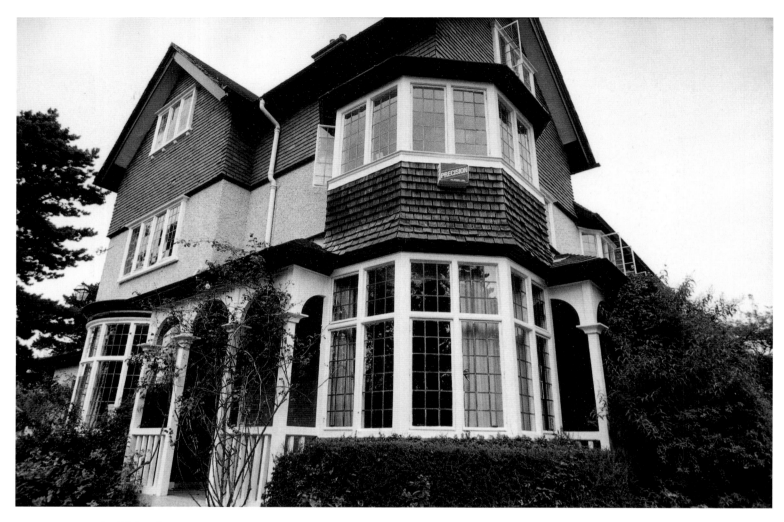

Cooldrinagh,
Samuel Beckett's birthplace,
Dublin 1990.

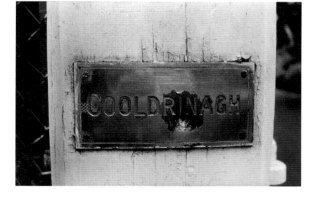

The Cooldrinagh
name-plate,
Dublin 1990.

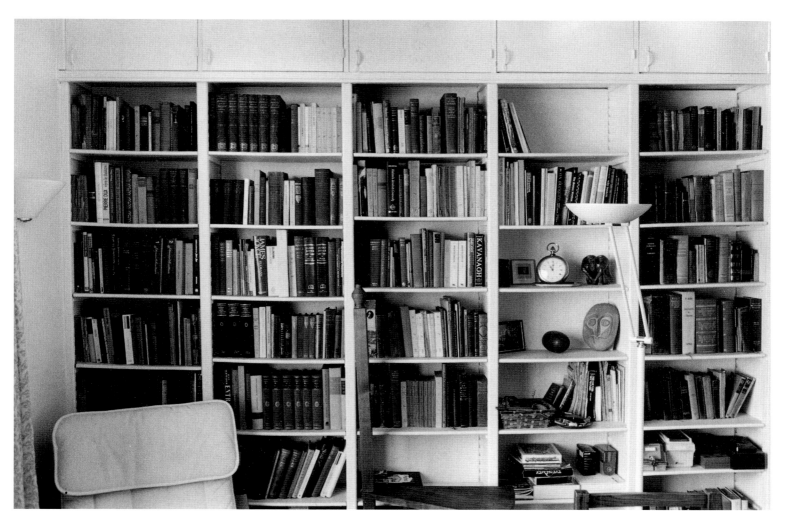

Bookshelves in the study of Beckett's flat in the Boulevard St-Jacques, Paris 1997.

The mail-boxes at the Boulevard St-Jacques, Paris 1985.

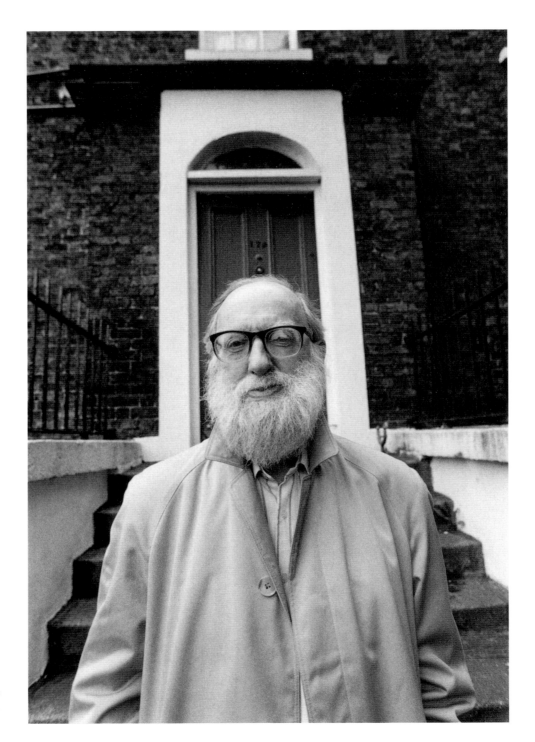

Pearse Hutchinson,
poet, Dublin 1997.

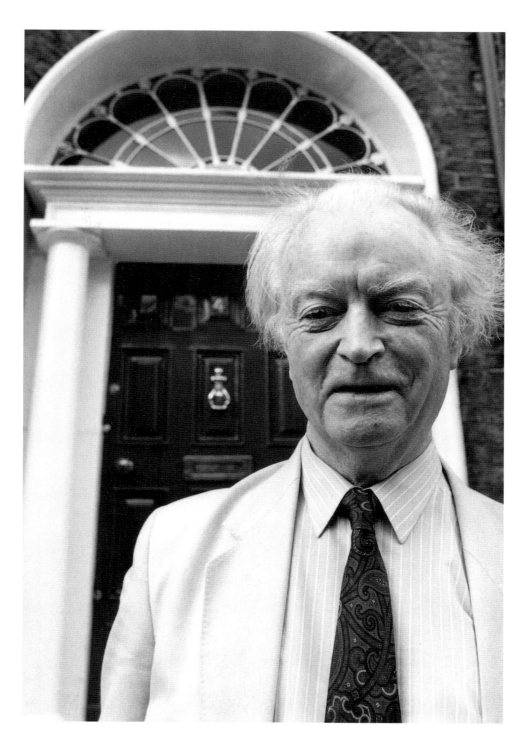

Benedict Kiely,
novelist and critic,
Dublin 1985.

17

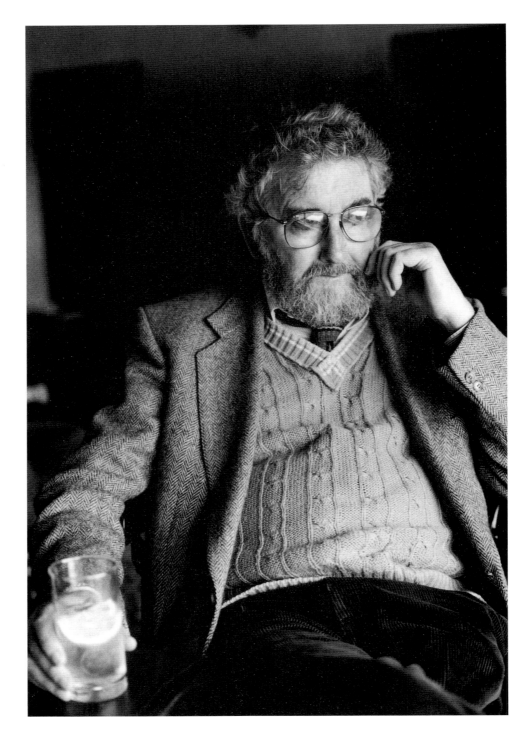

Aidan Higgins, novelist,
Cork 1997.

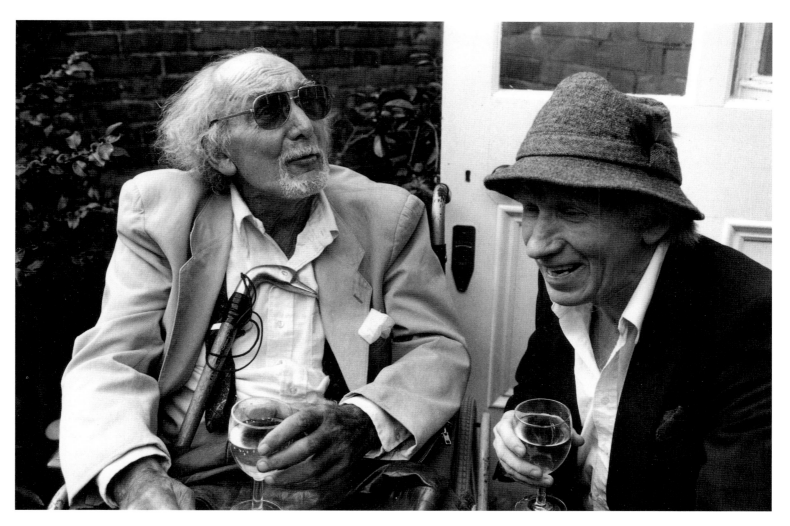

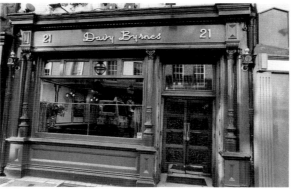

George Barker, poet,
and **Eddie Linden**,
poet and publisher,
London 1991.

Davy Byrne's Bar,
Dublin 1997.

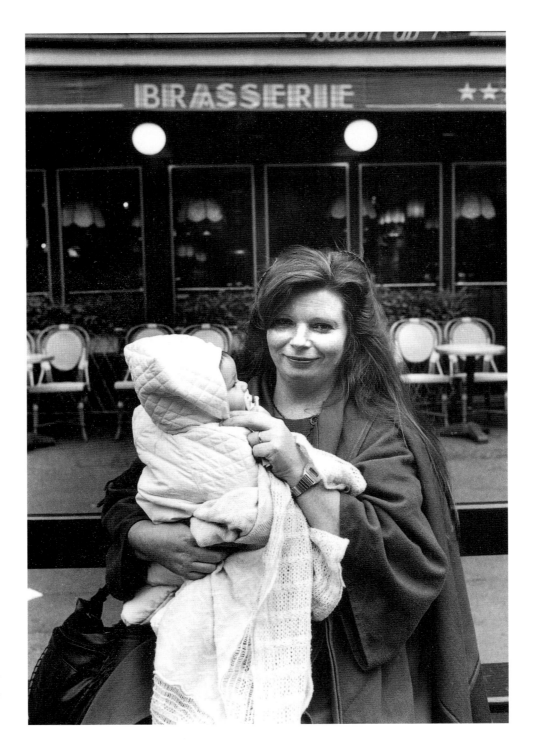

Nuala Ní Dhomhnaill,
poet, with her daughter,
Paris 1989.

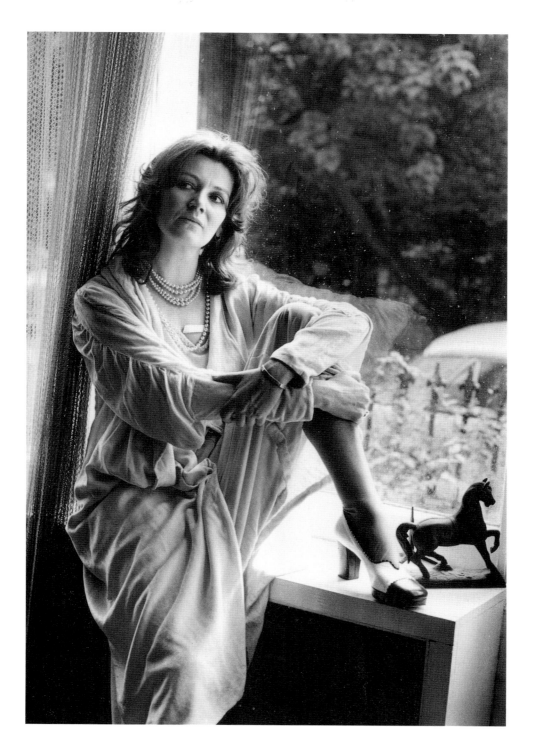

Edna O'Brien, novelist,
London 1971.

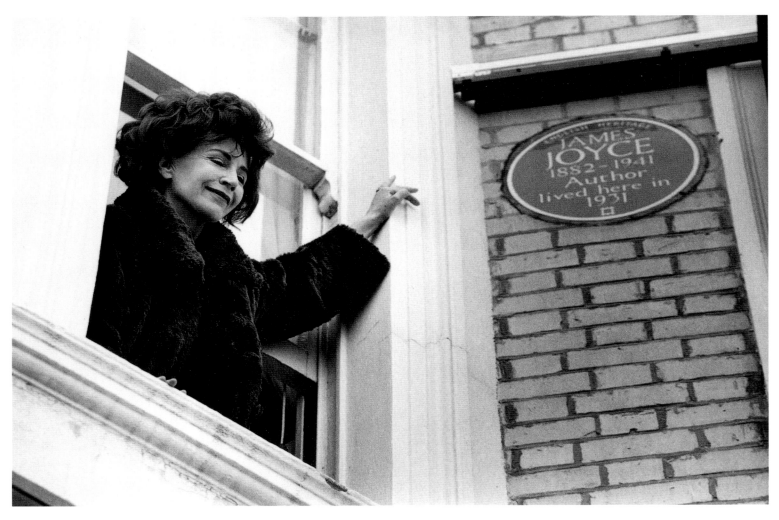

Edna O'Brien
at the unveiling of a
plaque to James Joyce,
London 1994.

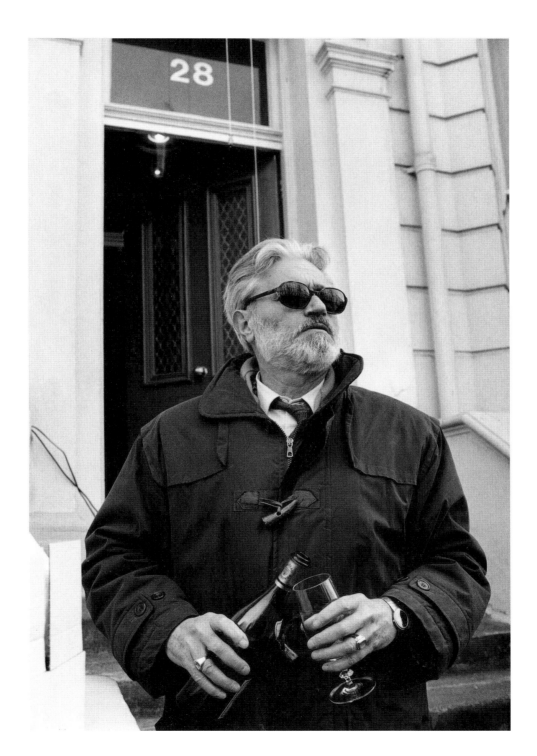

Stephen Joyce, the writer's grandson, at 28 Campden Grove, London 1994.

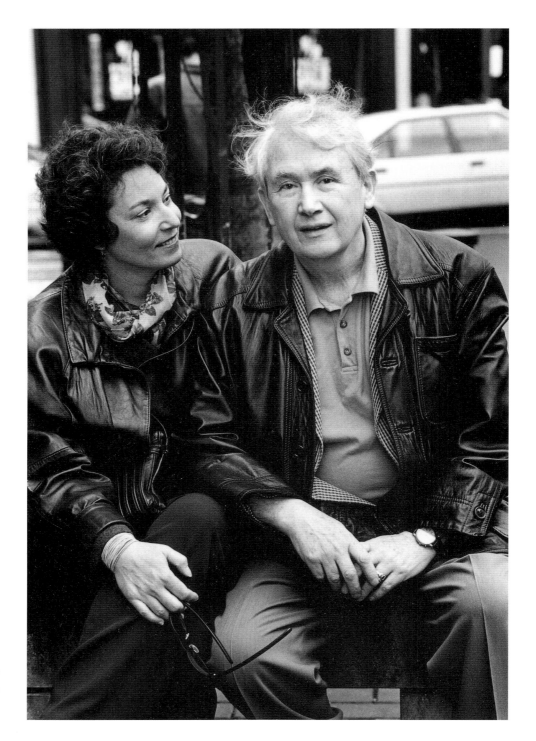

Frank McCourt,
novelist, and his wife Ellen,
Galway 1998.

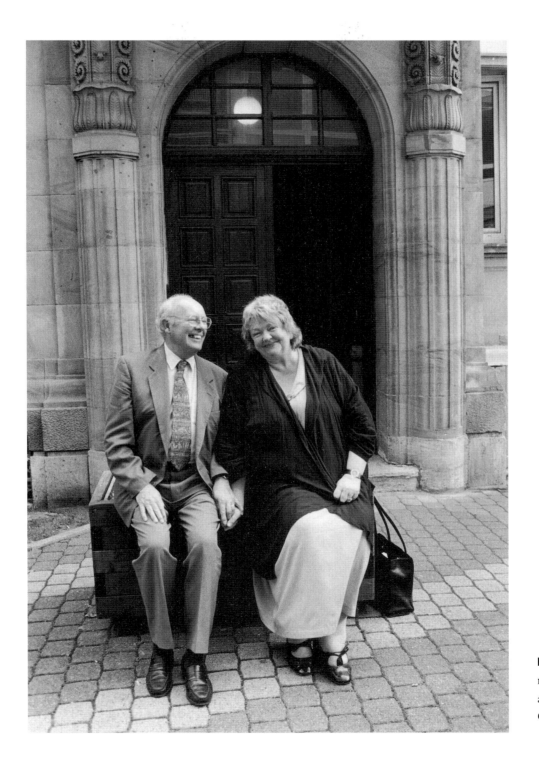

Maeve Binchy,
novelist and journalist,
and her husband Gordon,
Germany 1996.

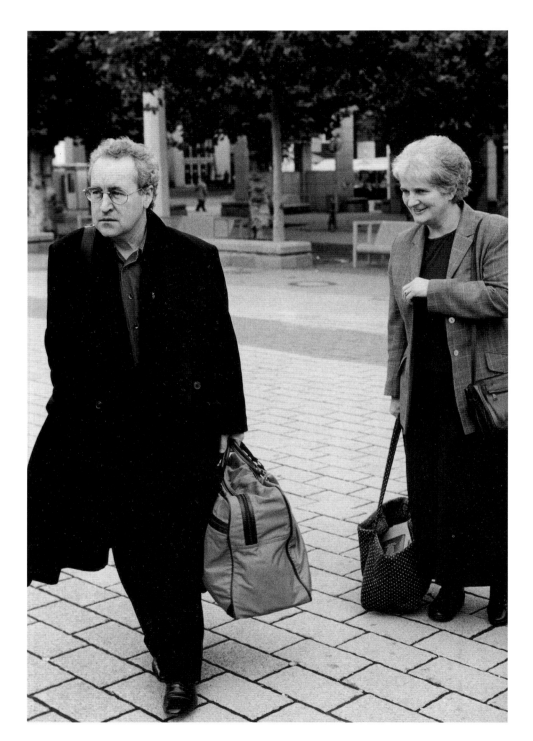

John Banville, novelist,
and **Edna Longley**, critic,
Frankfurt 1996.

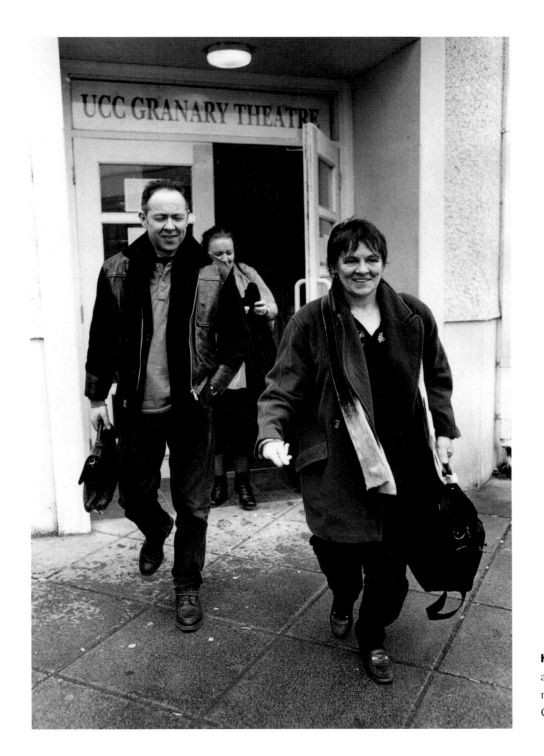

Hugo Hamilton, novelist, and **Evelyn Conlon**, novelist and playwright, Cork 1998.

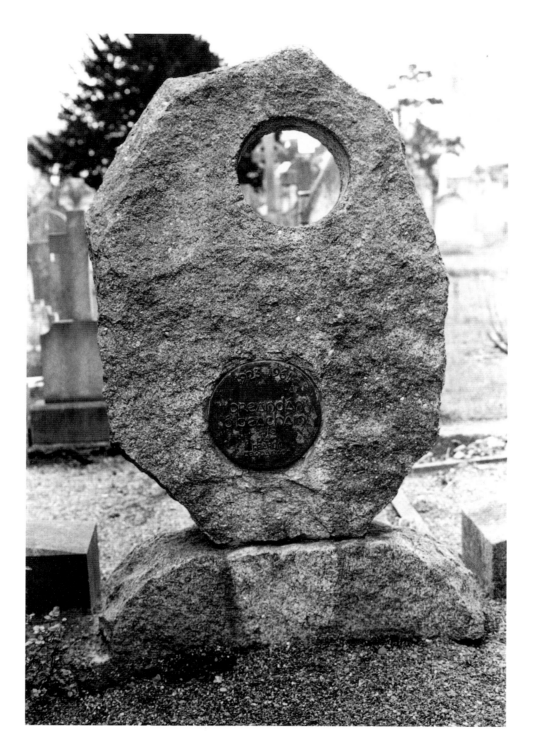

Grave of
Brendan Behan,
playwright,
Dublin 1996.

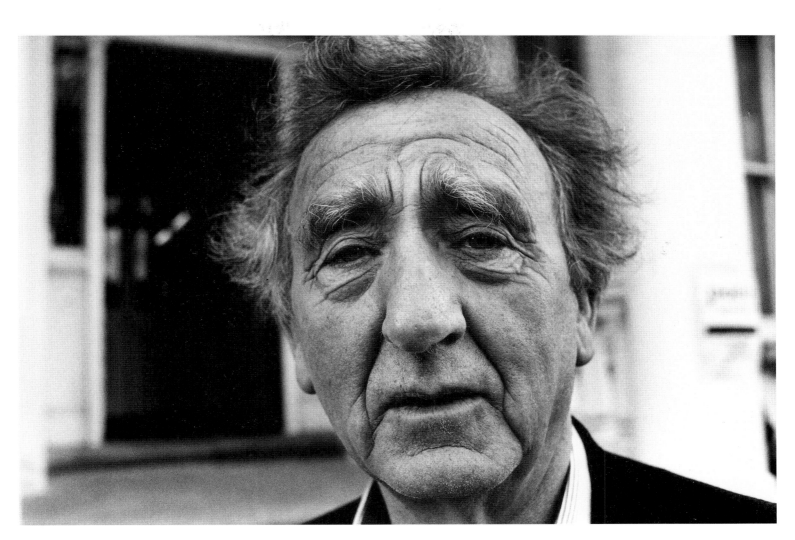

Brian Behan,
playwright and
brother of Brendan,
London 1985.

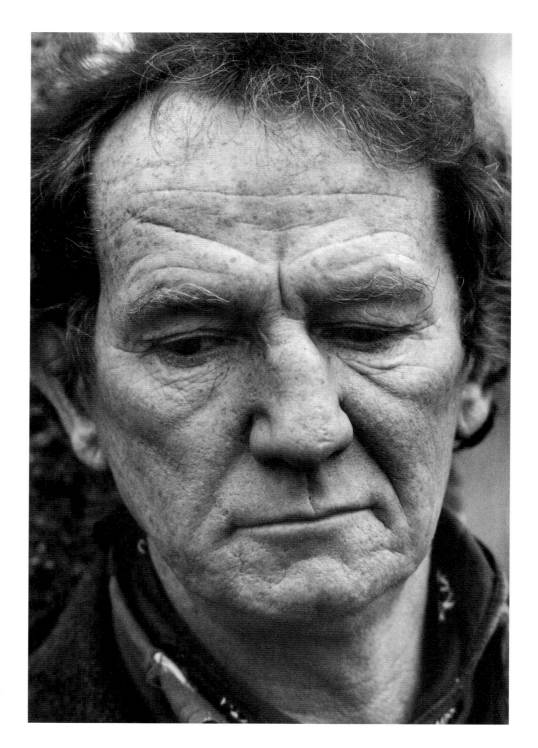

Desmond O'Grady, poet,
Kinsale, Co. Cork, 1989.

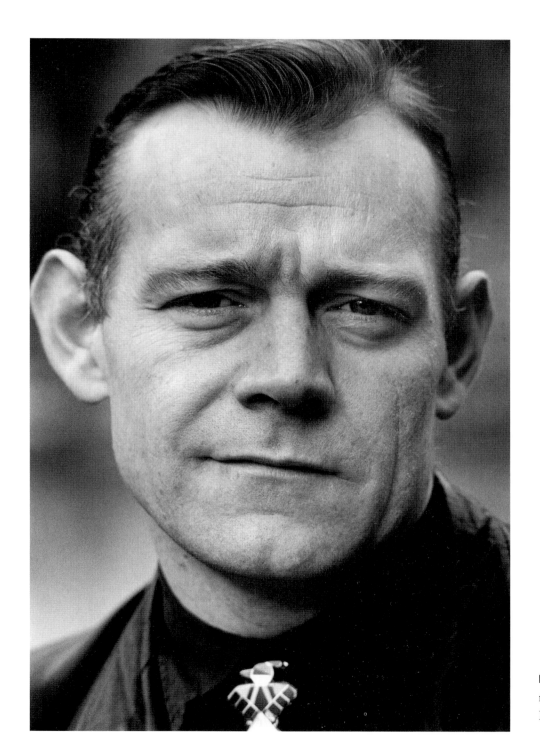

Mannix Flynn,
novelist and playwright,
London 1987.

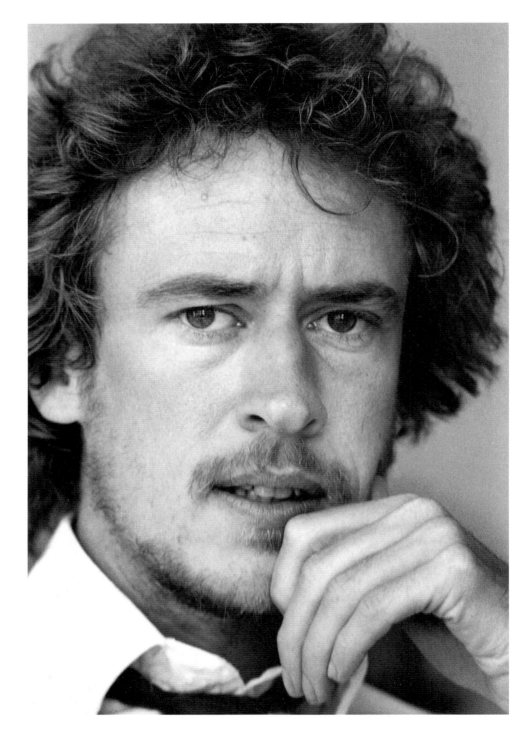

Timothy O'Grady,
novelist, London 1987.

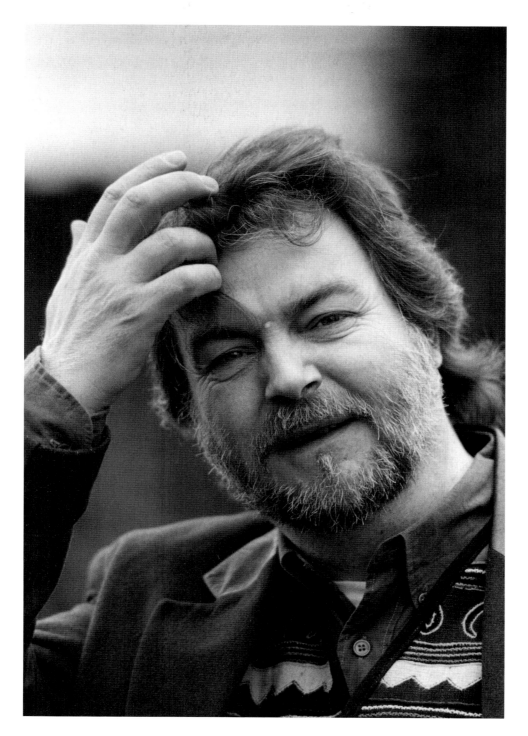

Fred Johnston, poet, Galway 1998.

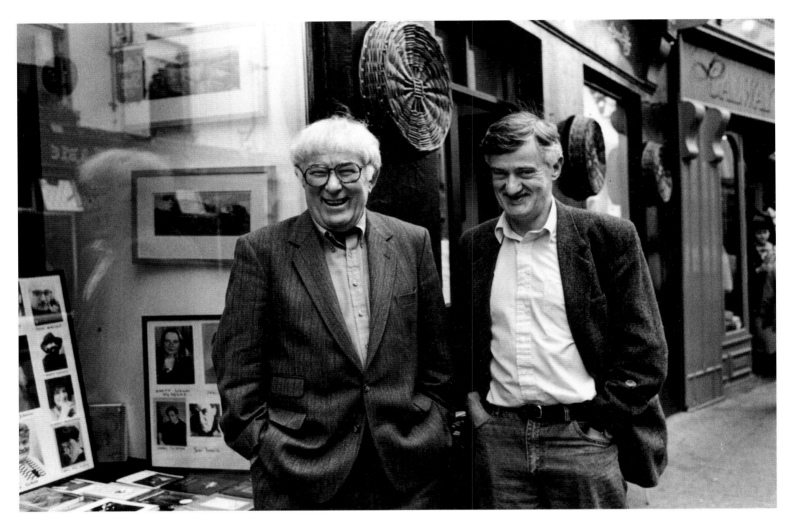

Seamus Heaney, poet and Nobel Prizewinner, and **Bernard O'Donoghue**, poet, Galway 1998.

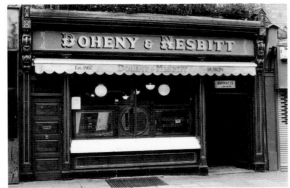

Doheny & Nesbitt's Bar, Dublin 1997.

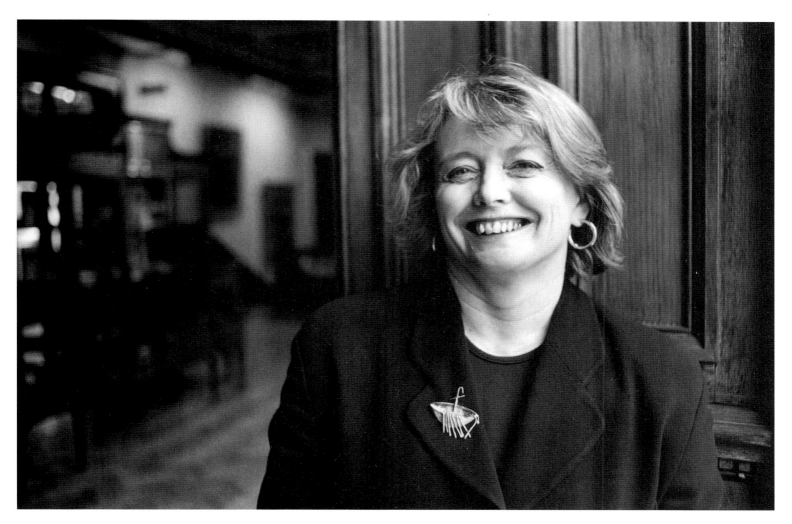

Marie Heaney, writer,
Cork 1998.

The Bailey,
Dublin 1997.

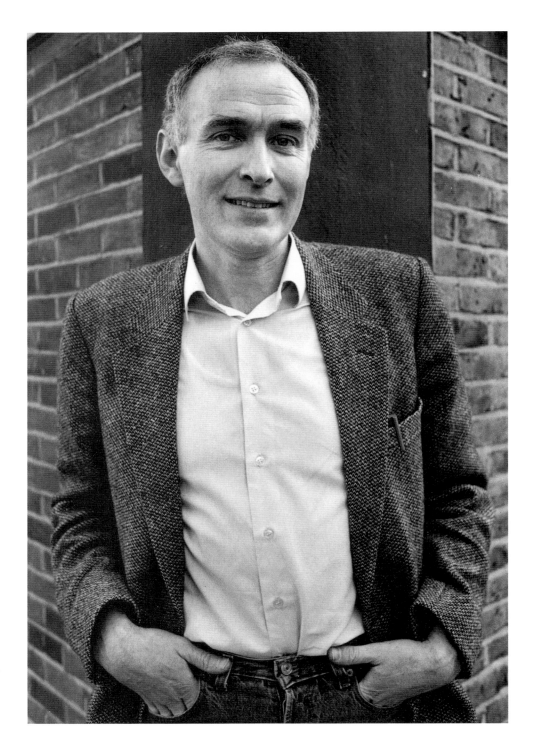

Shane Connaughton,
actor, novelist
and scriptwriter,
London 1987.

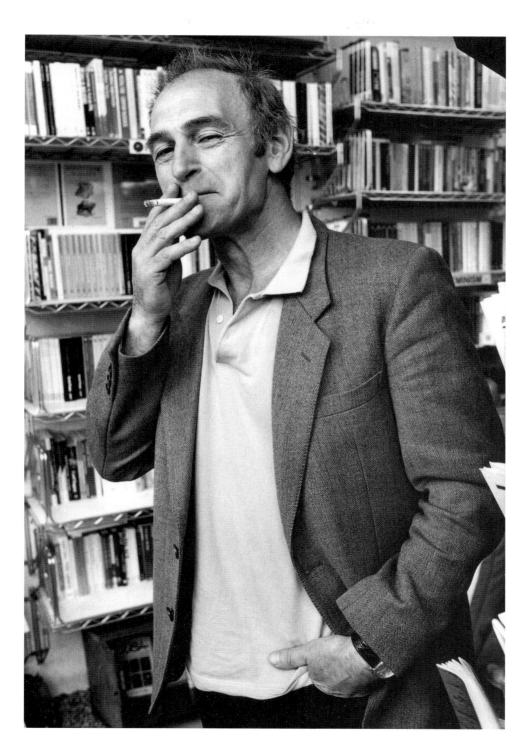

Tom Murphy,
playwright,
London 1987.

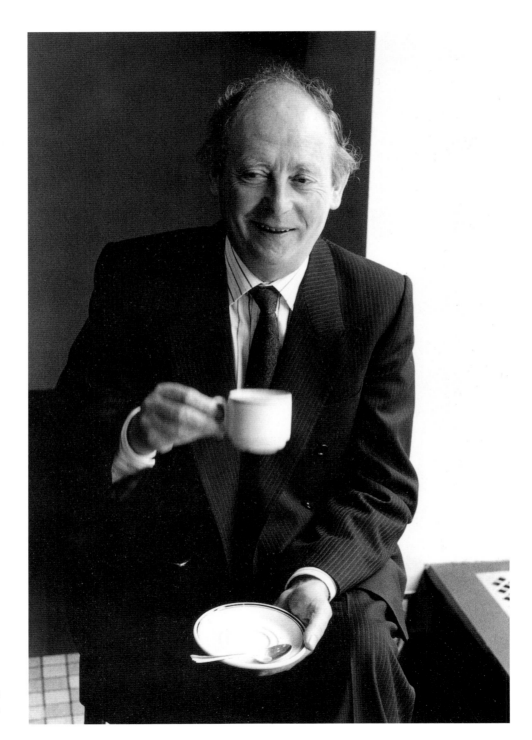

John McGahern, *novelist,*
Dublin 1991.

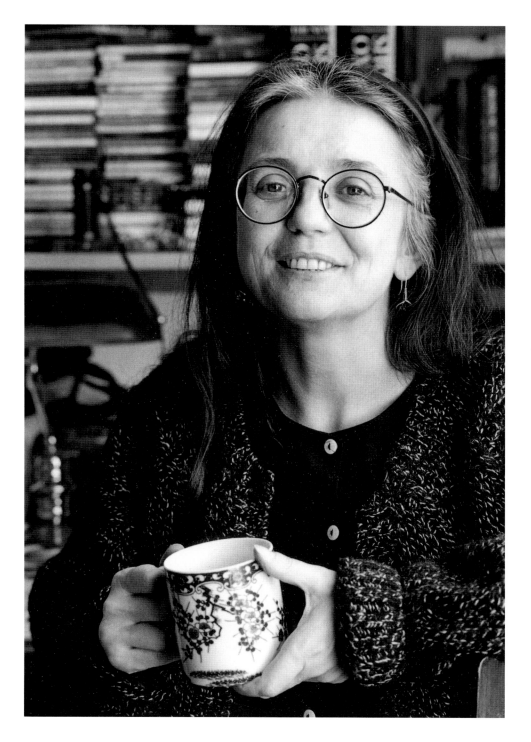

Paula Meehan, poet,
Dublin 1998.

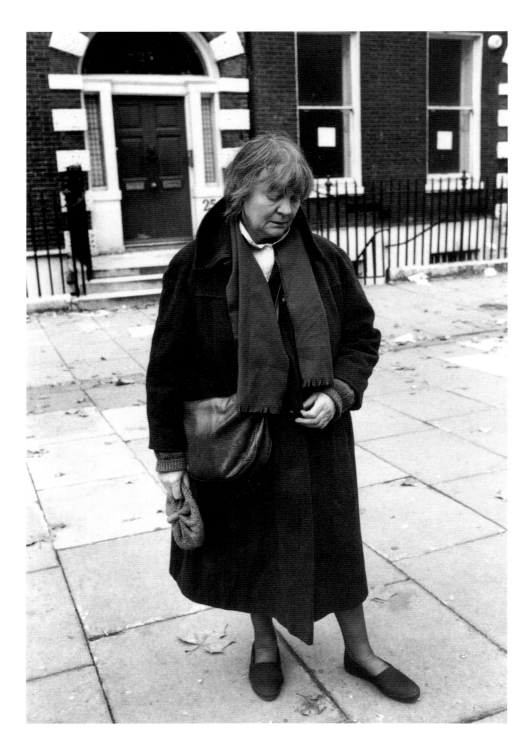

Iris Murdoch, novelist,
London 1987.

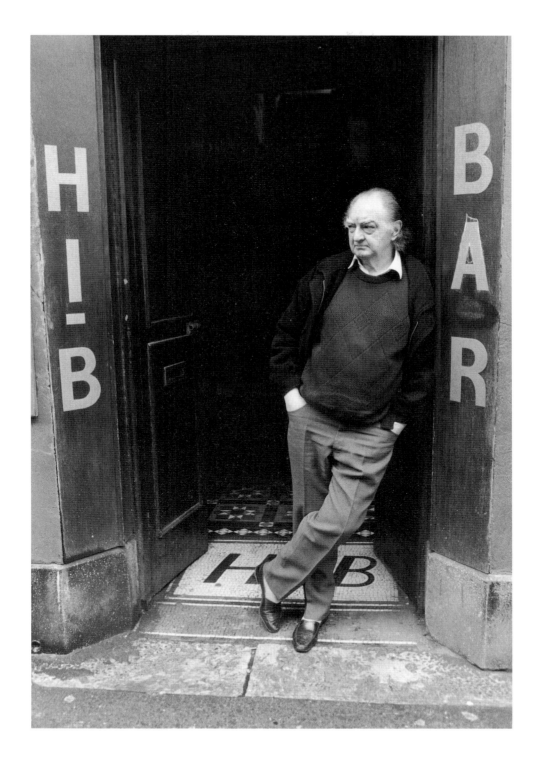

Patrick Galvin,
poet and playwright,
Cork 1996.

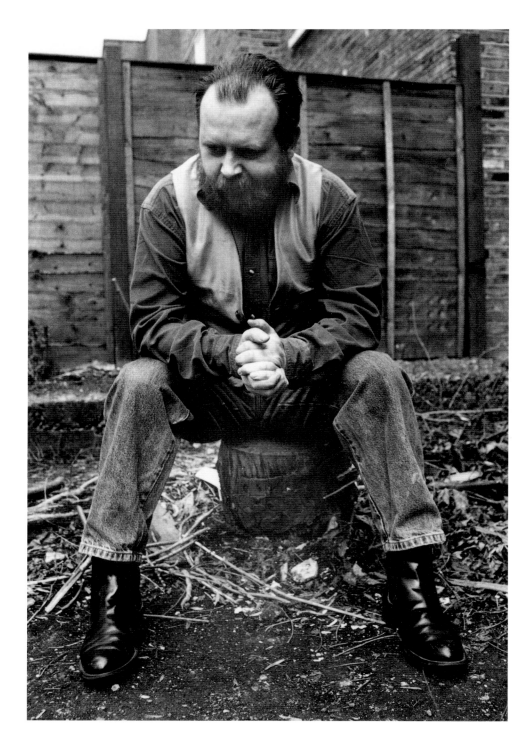

Patrick McCabe, novelist,
London 1995.

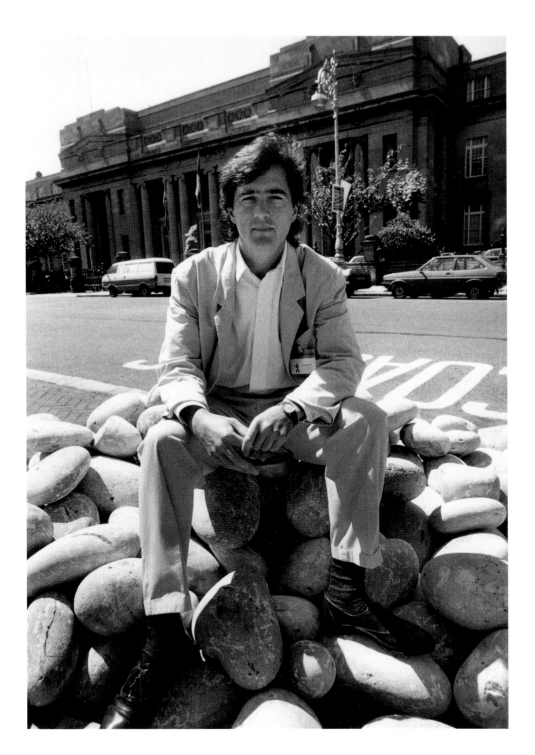

Sebastian Barry,
playwright,
Dublin 1991.

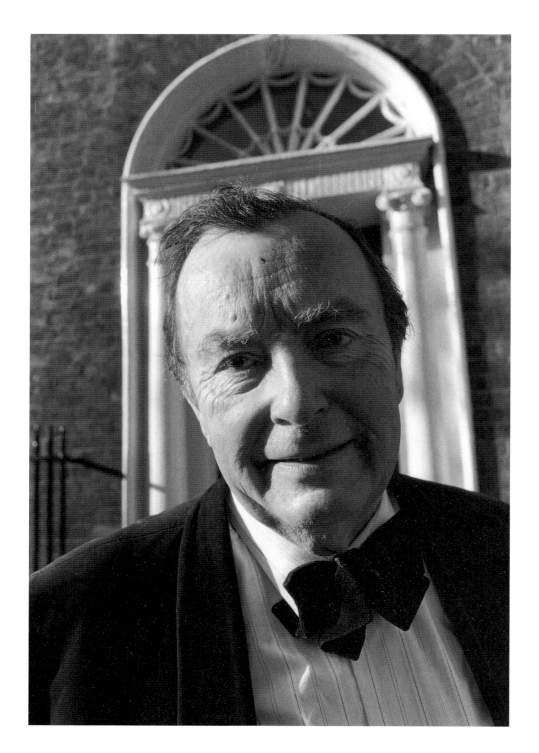

John Ryan,
writer and editor,
Dublin 1982.

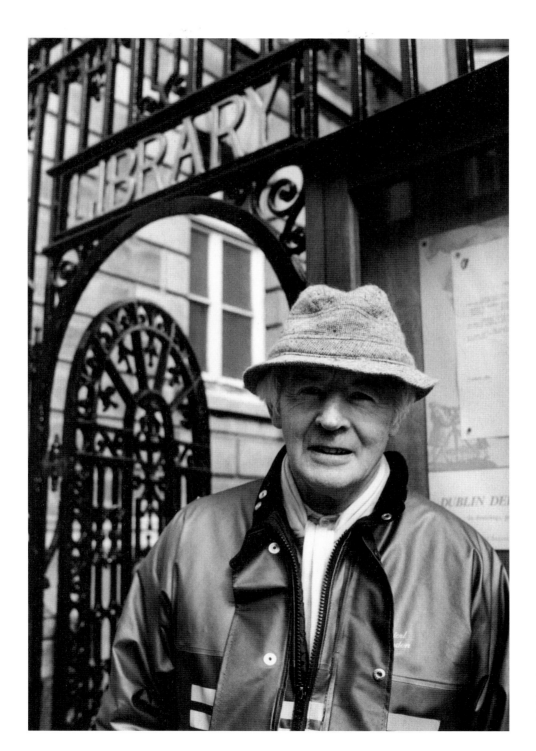

Ulick O'Connor,
poet and journalist,
Dublin 1990.

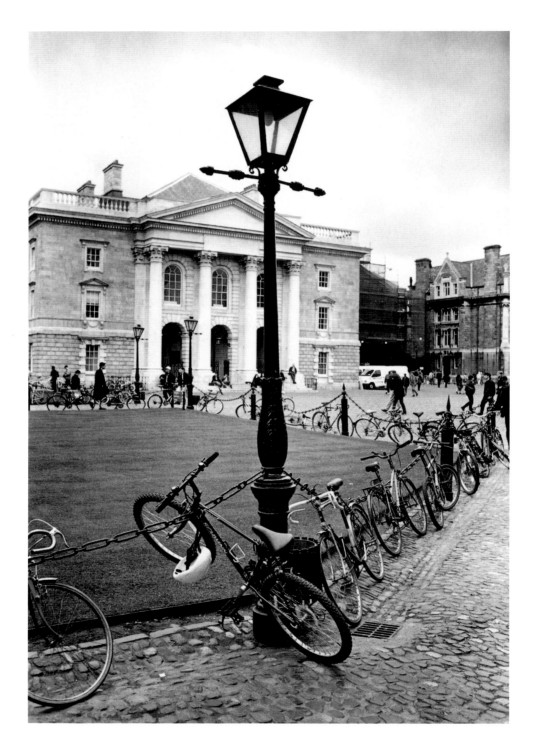

Trinity College,
Dublin 1996.

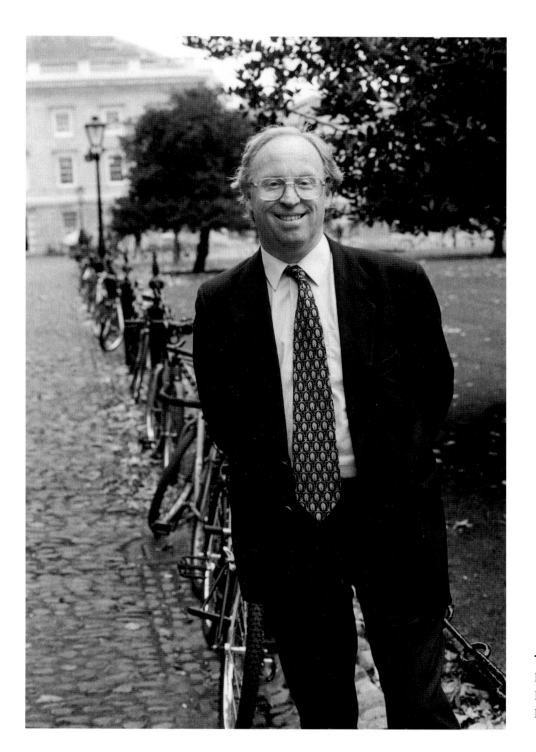

Terence Brown,
Professor of Anglo-Irish
Literature at Trinity College,
Dublin 1996.

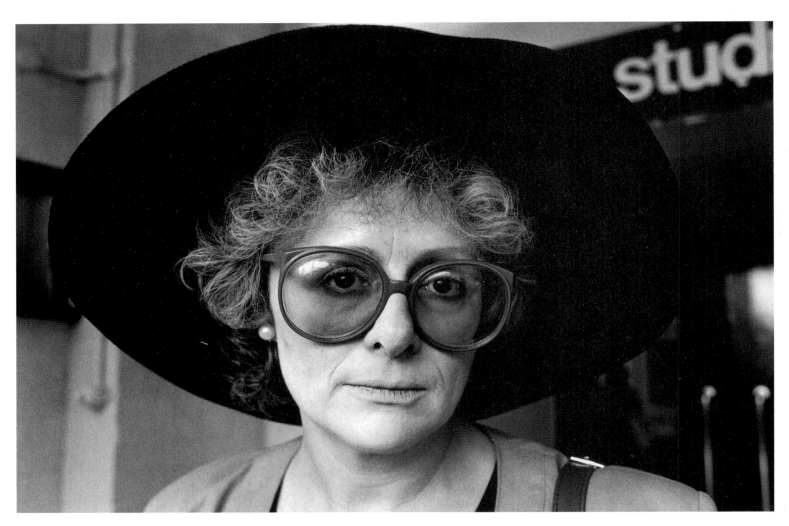

Mary Kenny, journalist,
London 1987.

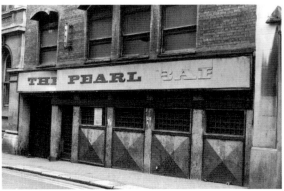

The Pearl Bar,
Dublin 1997.

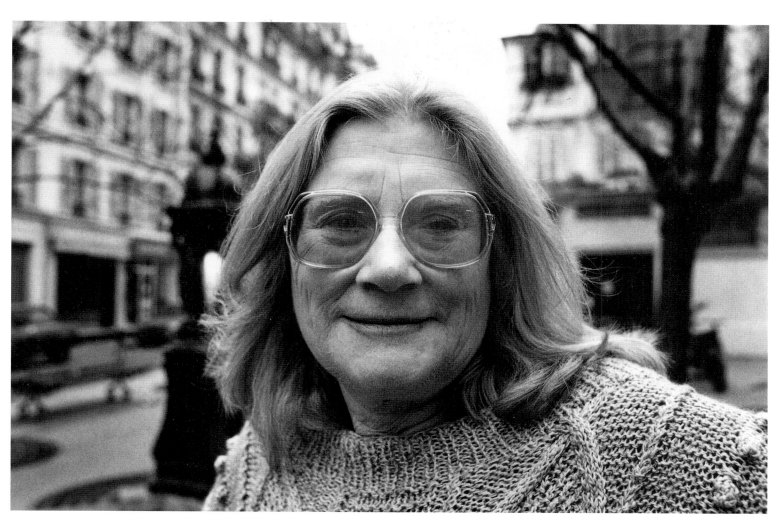

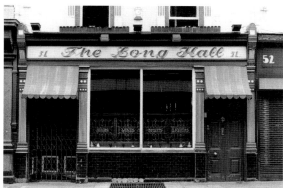

Jennifer Johnston,
novelist,
Paris 1989.

The Long Hall,
Dublin 1997.

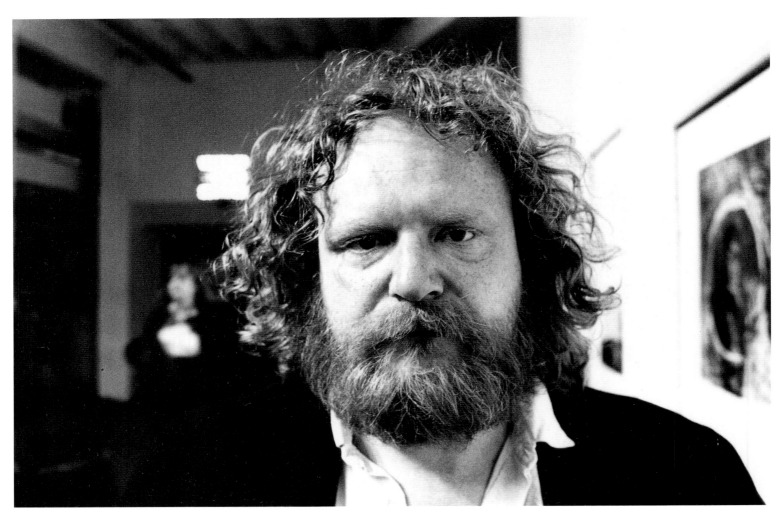

Frank McGuinness,
playwright,
London 1987.

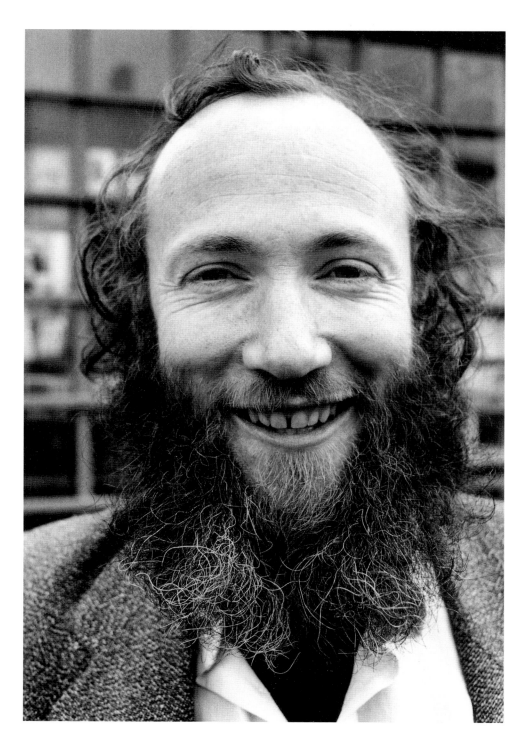

Dermot Bolger, poet,
novelist and playwright,
London 1987.

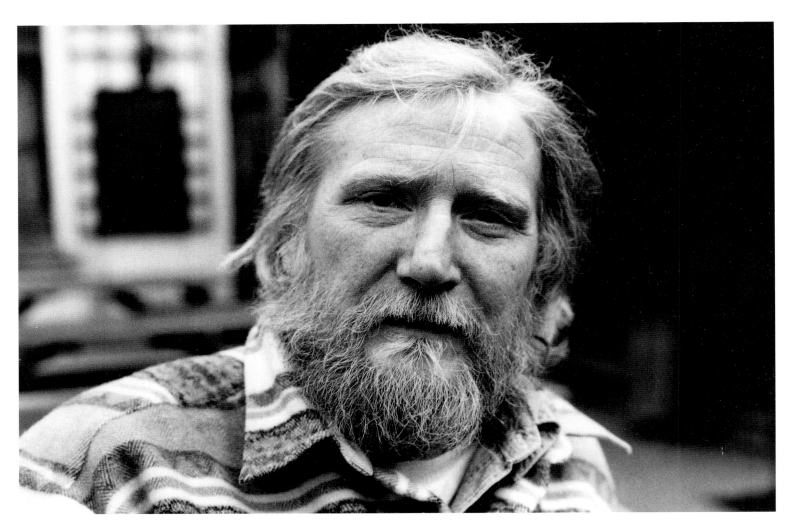

Dermot Healy,
poet and novelist,
Sligo 1996.

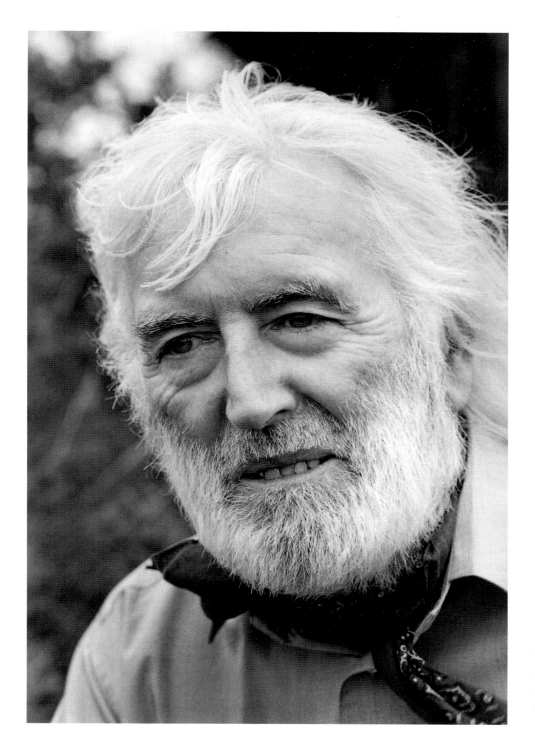

Tom MacIntyre,
poet, playwright
and novelist,
Cavan 1998.

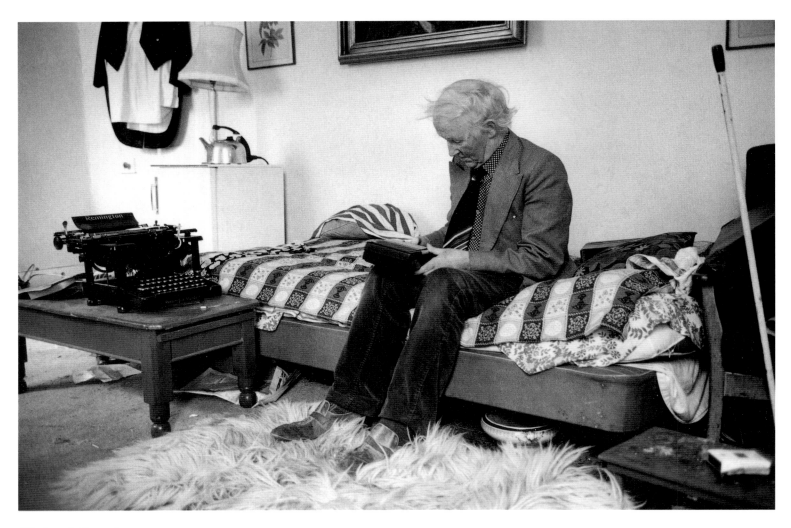

Michael Mannion, poet,
London 1976.

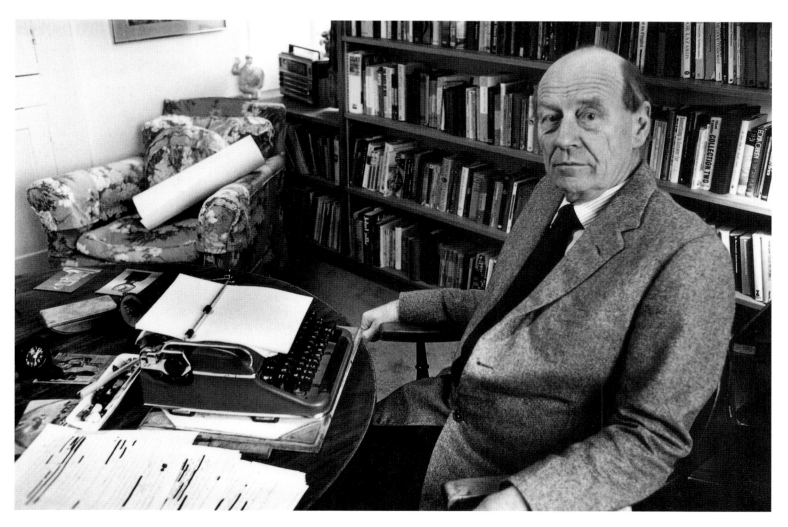

William Trevor, *novelist,*
Devon 1982.

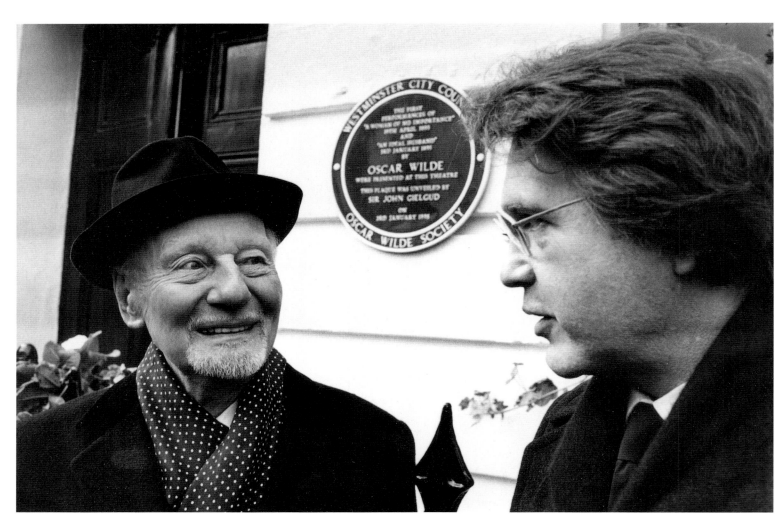

Sir John Gielgud with
Merlin Holland,
Oscar Wilde's grandson,
unveiling a plaque to Wilde
at the Theatre Royal,
Haymarket, London 1995.

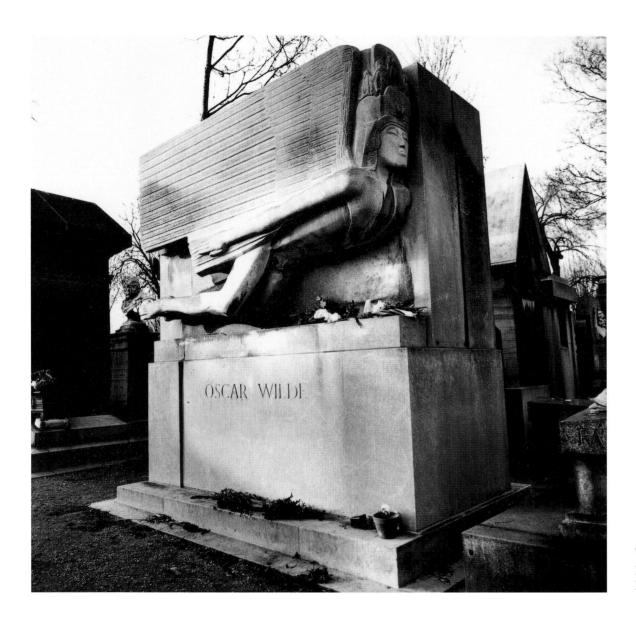

Grave of **Oscar Wilde**,
playwright and wit,
Paris 1985.

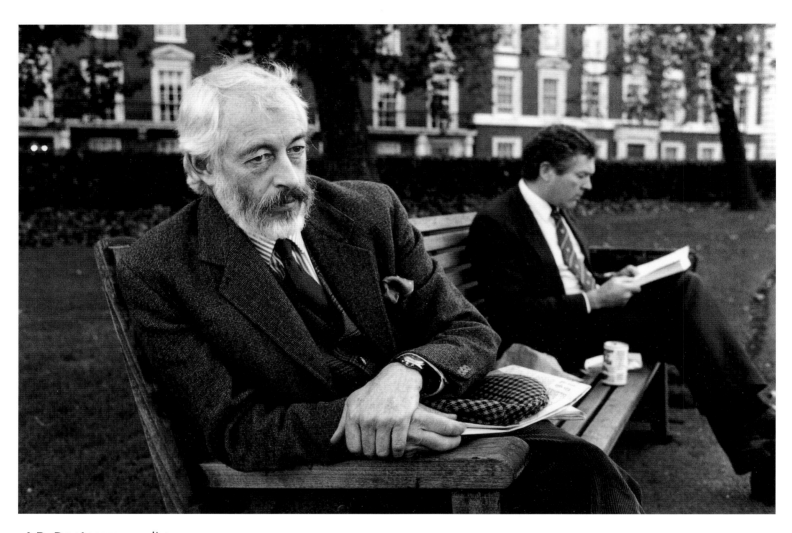

J.P. Donleavy, novelist,
London 1988.

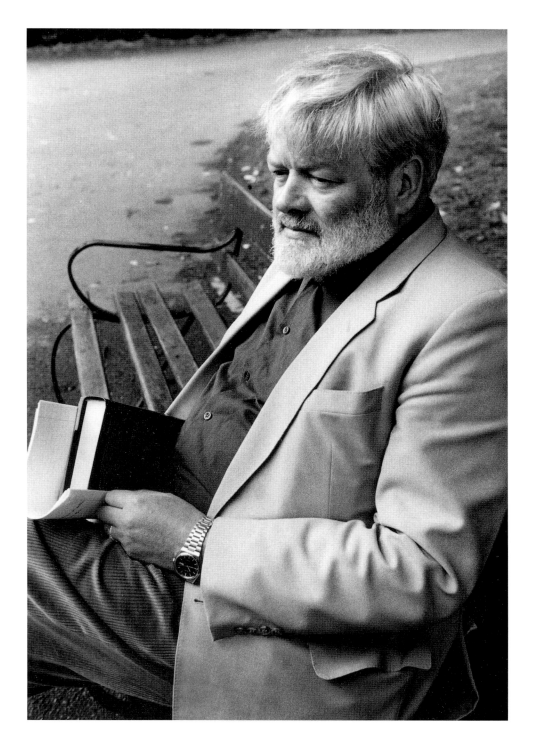

Michael Longley, poet,
Dublin 1991.

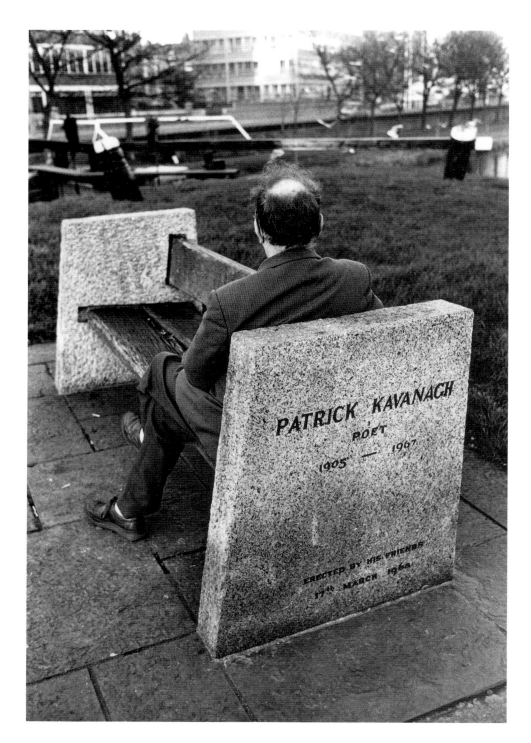

Memorial seat to
Patrick Kavanagh, poet,
Dublin 1987.

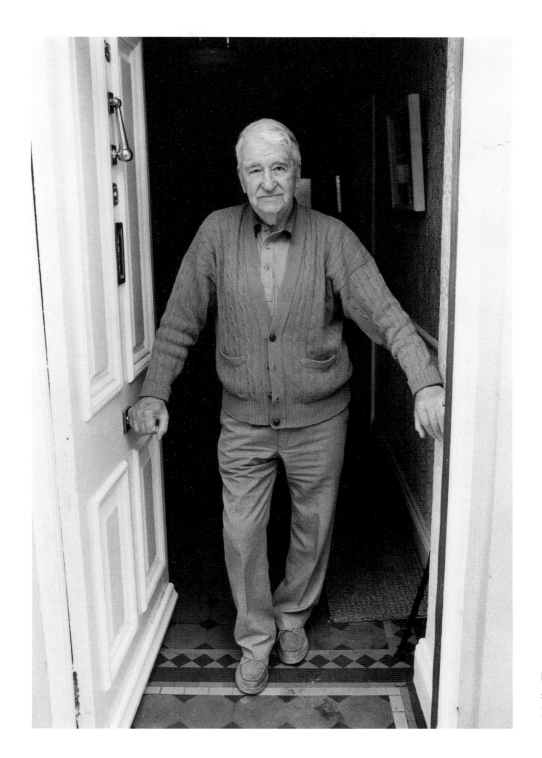

Bryan MacMahon,
short-story writer,
Listowel, Co. Kerry, 1997.

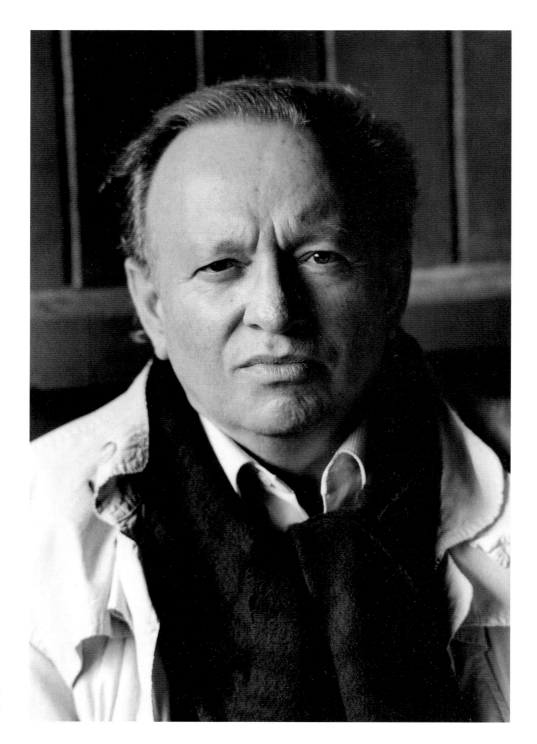

Derek Mahon, poet,
Dublin 1997.

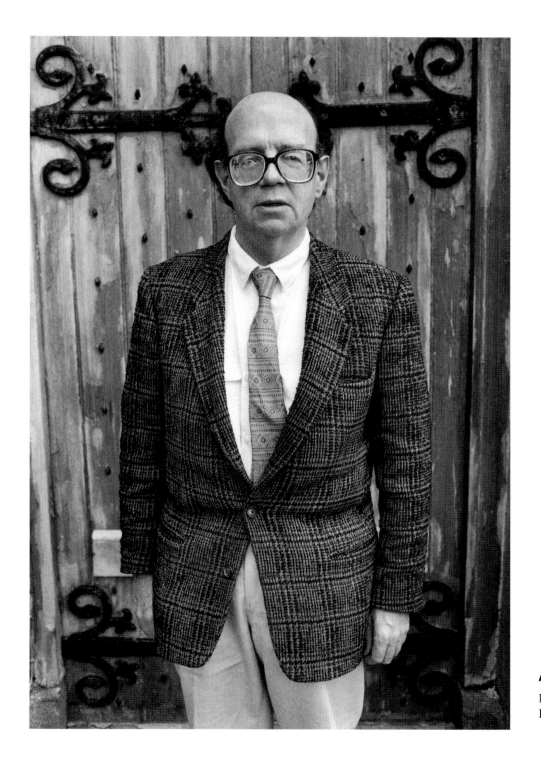

Anthony Cronin,
poet and critic,
Kinsale, Co. Cork, 1989.

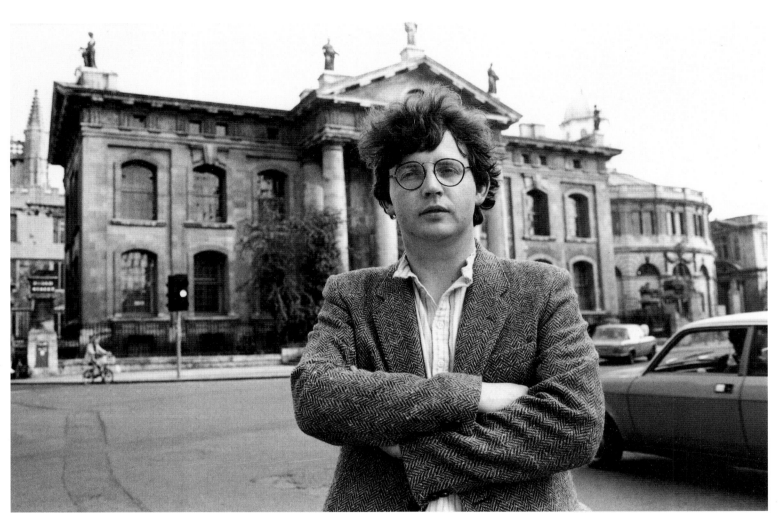

Paul Muldoon, poet,
Oxford 1986.

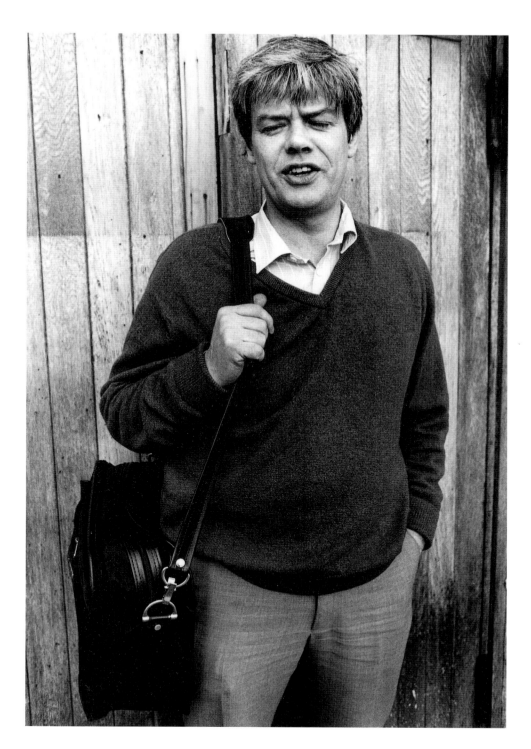

Bernard MacLaverty,
novelist, London 1987.

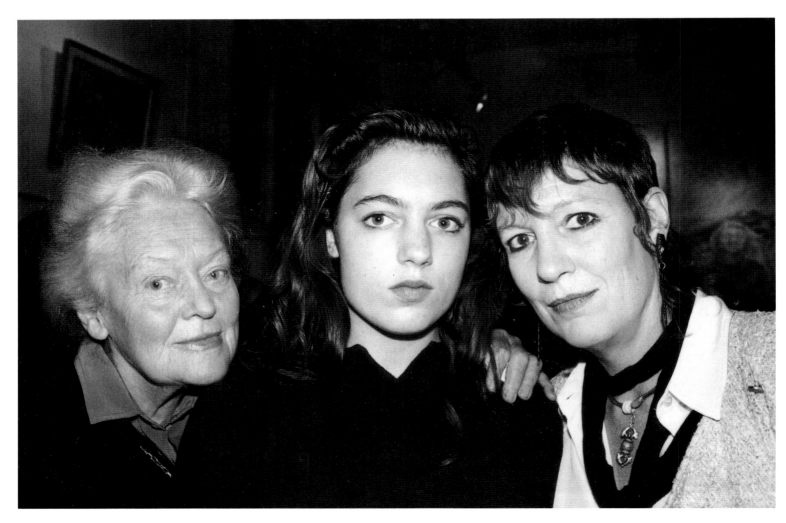

Three generations of the
MacNeice family:
(left to right)
Hedli, widow of Louis;
Ishshah, granddaughter;
and Corinna, daughter,
London 1989.

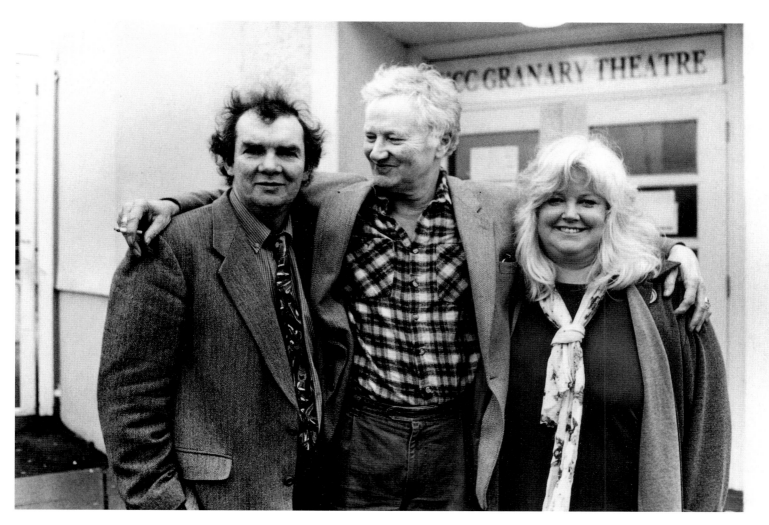

(left to right)
Thomas McCarthy, poet;
James Simmons, poet; and
Janice Fitzpatrick, poet
and wife of James Simmons,
Cork 1998.

The Palace Bar,
Dublin 1997.

Eiléan Ní Chuilleanáin,
poet, London 1996.

Martina Evans, novelist,
London 1996.

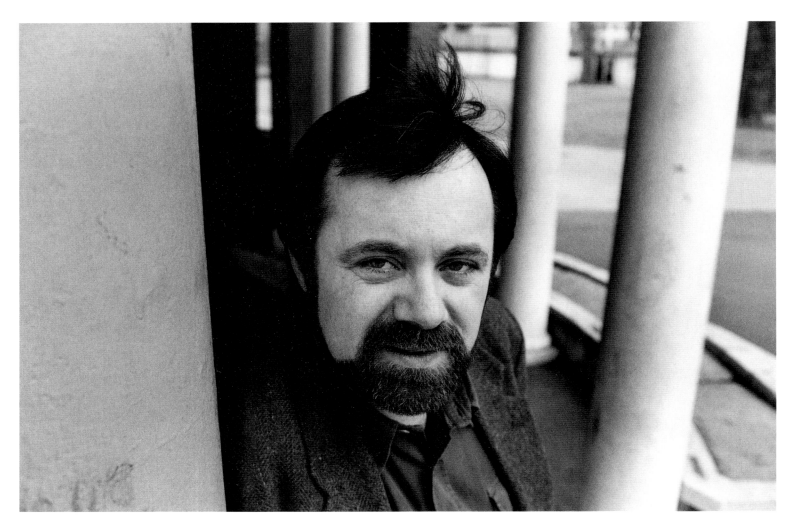

Matthew Sweeney, poet,
London 1989.

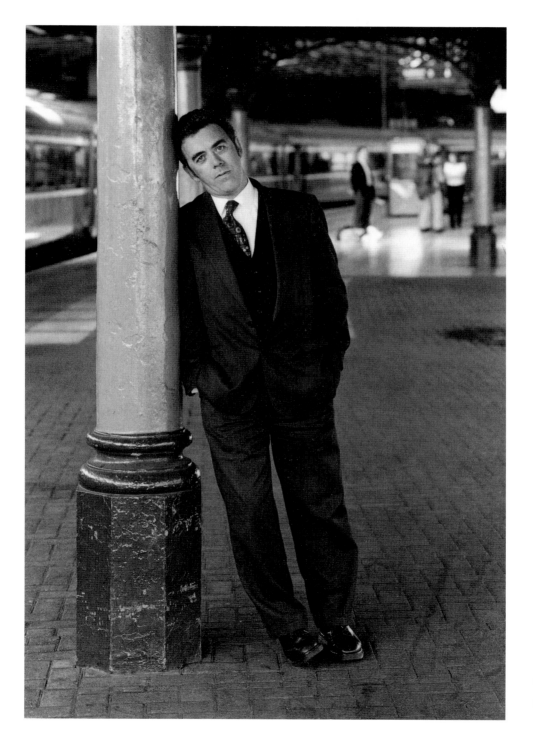

Theo Dorgan, poet,
Cork 1997.

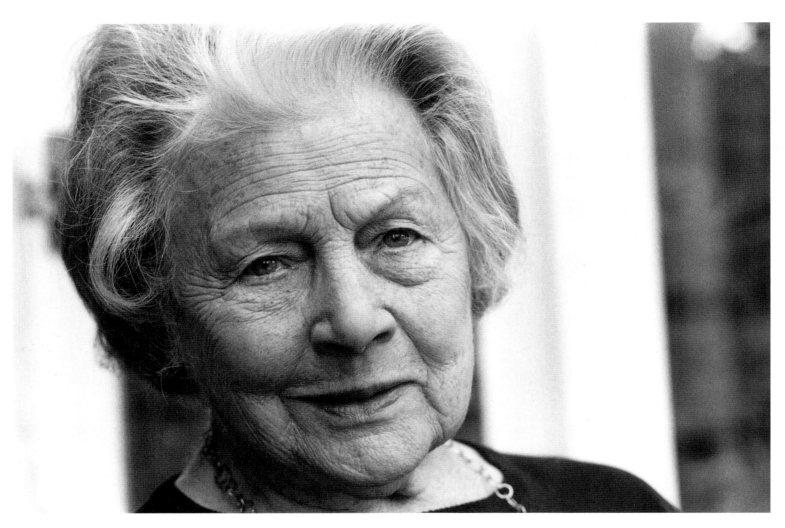

Eileen O'Casey,
writer and widow
of Sean O'Casey,
London 1987.

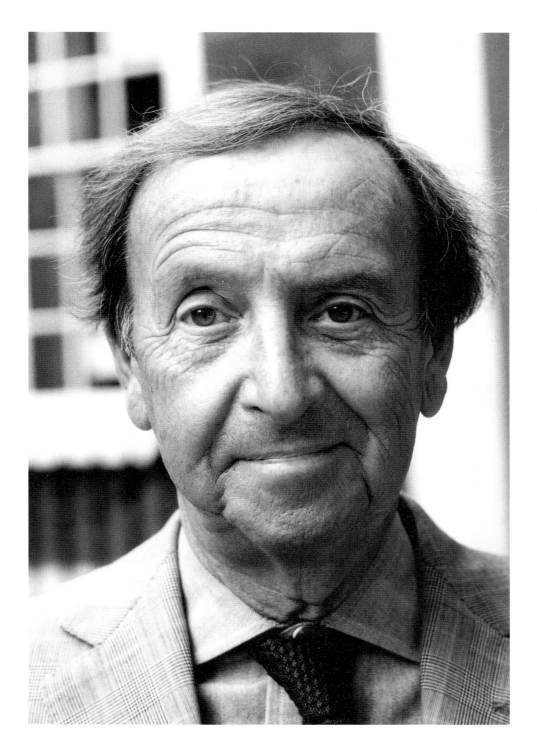

Brian Moore, novelist, London 1985.

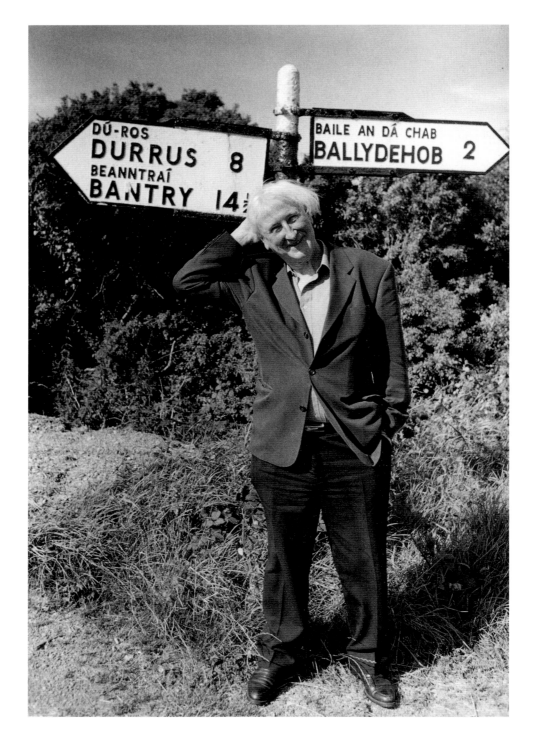

John Montague, poet,
Ballydehob, Co. Cork, 1997.

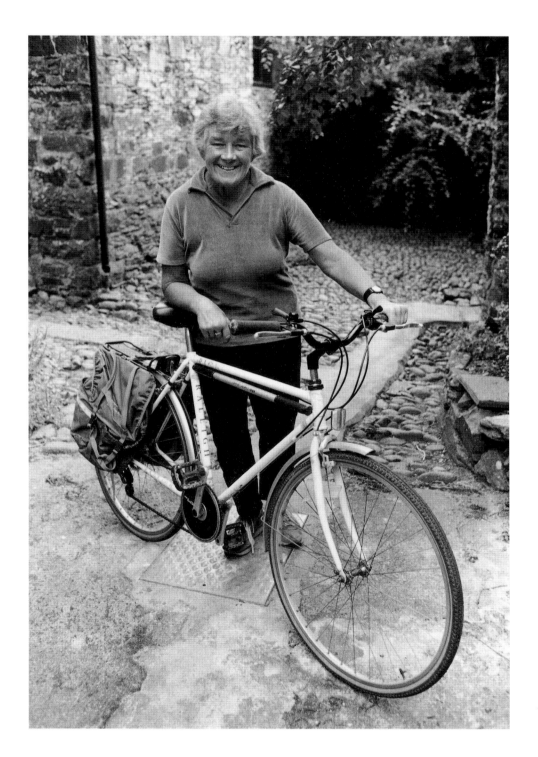

Dervla Murphy, travel writer, Waterford 1997.

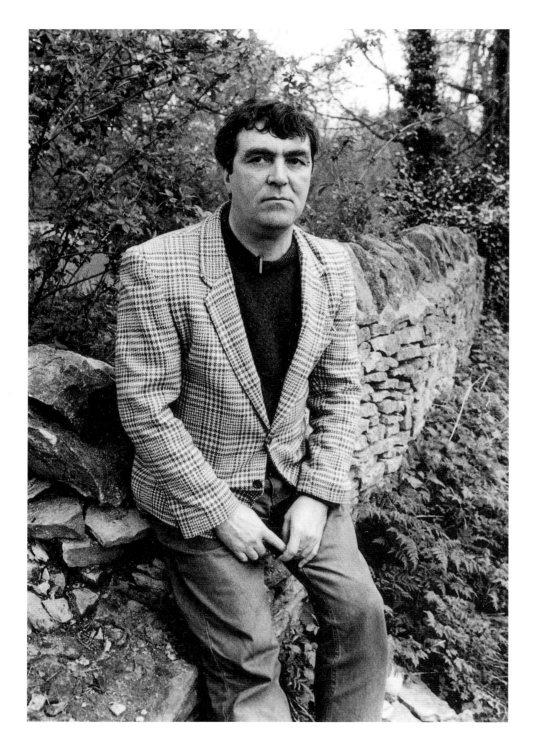

Brendan Hamill, poet,
Chipping Norton,
Oxfordshire, 1994.

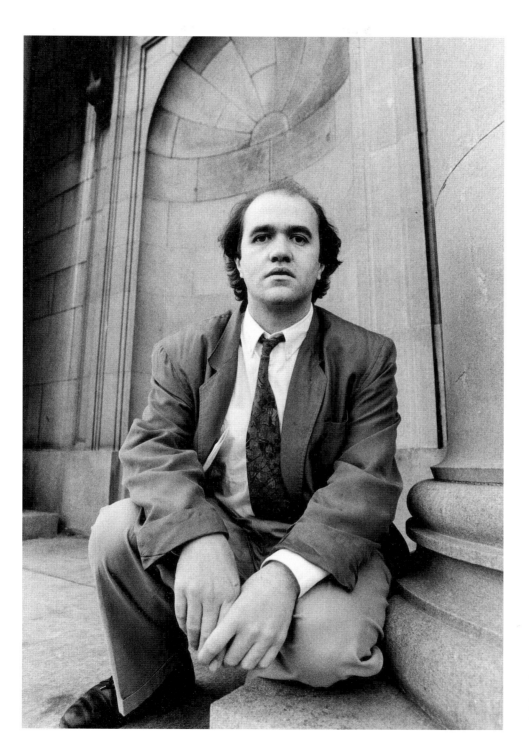

Colm Tóibín,
novelist, journalist and critic,
Dublin 1991.

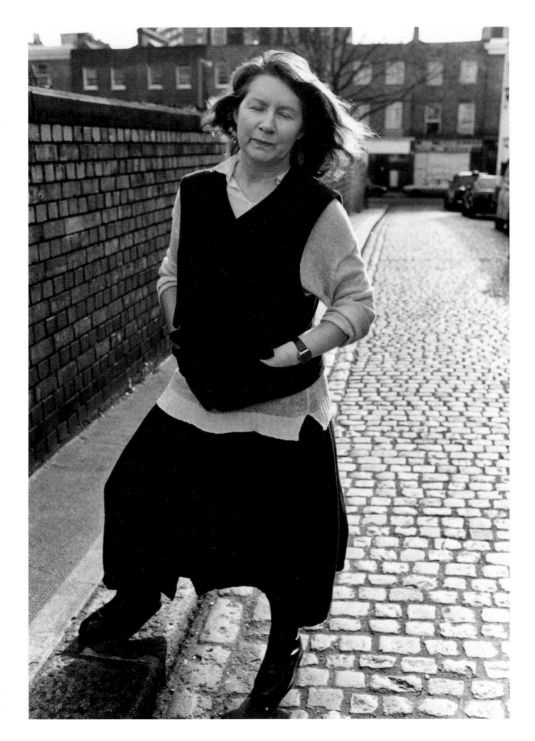

Medbh McGuckian, poet,
London 1996.

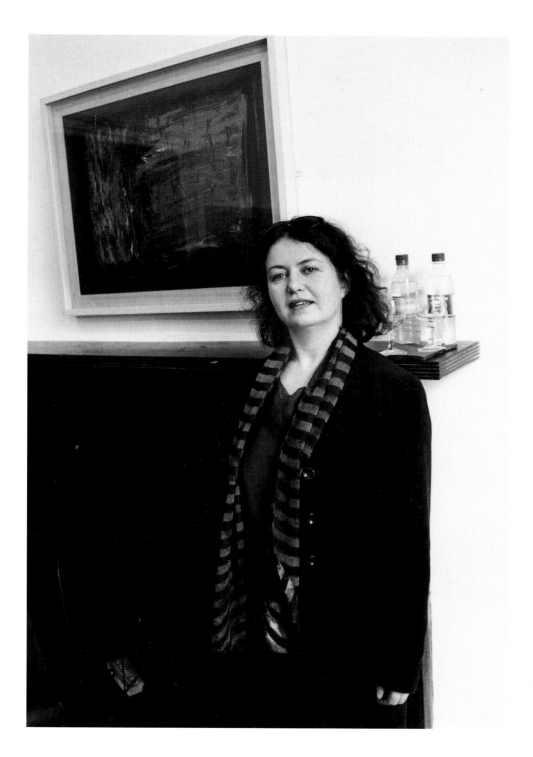

Anne Haverty,
novelist, Galway 1997.

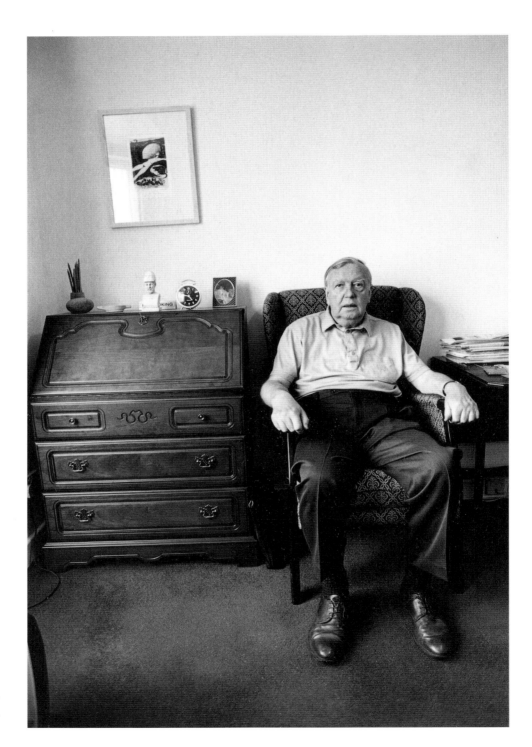

Robert Greacen, poet,
Dublin 1998.

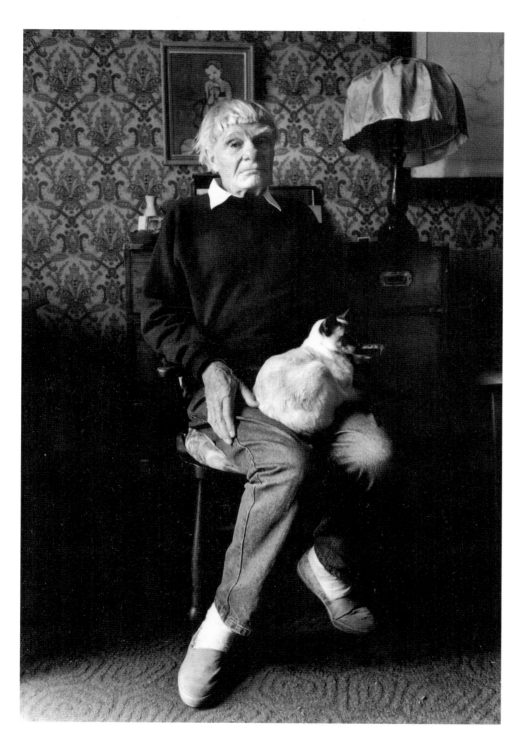

Francis Stuart,
novelist, Dublin 1991.

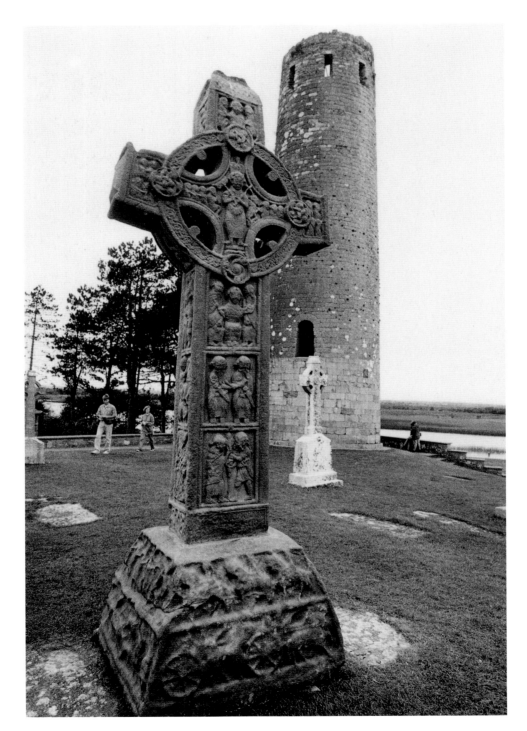

Clonmacnois,
the monastery graveyard,
Co. Offaly 1991.

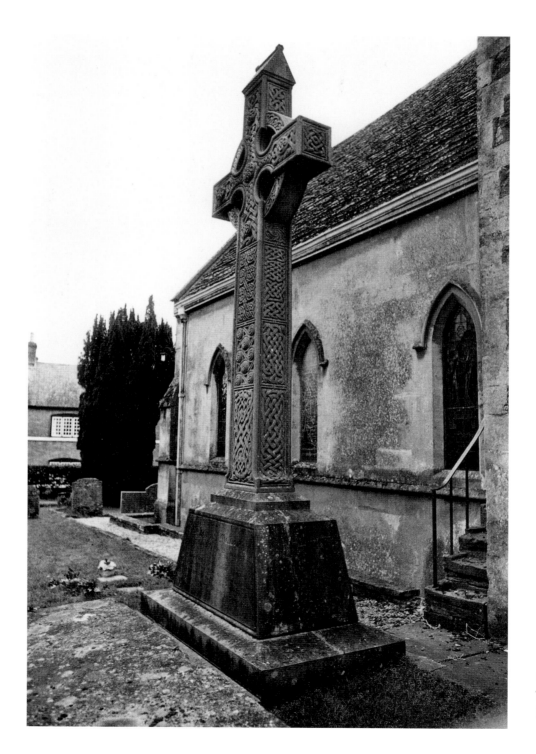

Grave of
Thomas Moore, poet,
Bromham, Wiltshire, 1995.

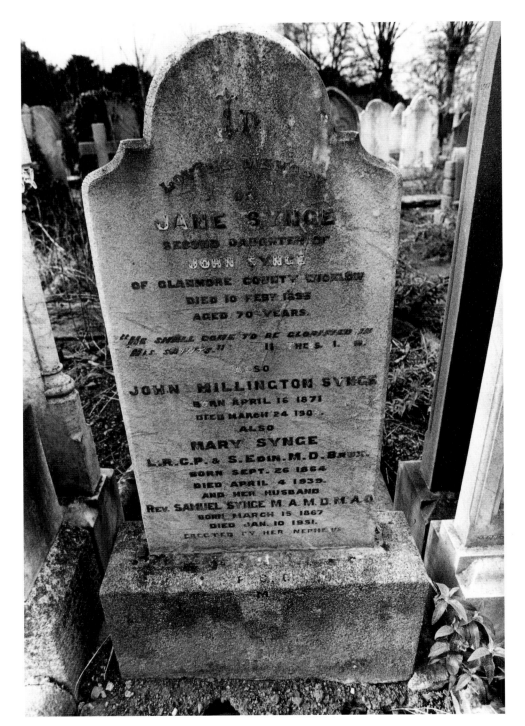

Grave of
John Millington Synge,
playwright, Dublin 1998.

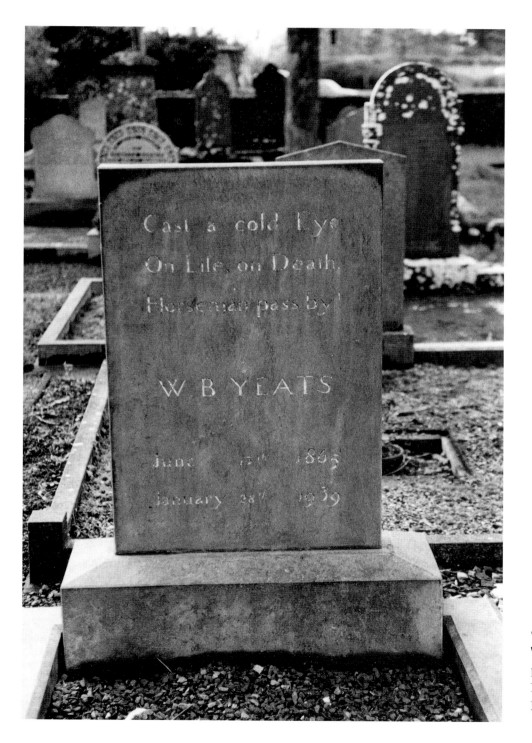

Grave of
William Butler Yeats,
poet, folklorist, and
Nobel Prizewinner,
Drumcliff, Co. Sligo, 1996.

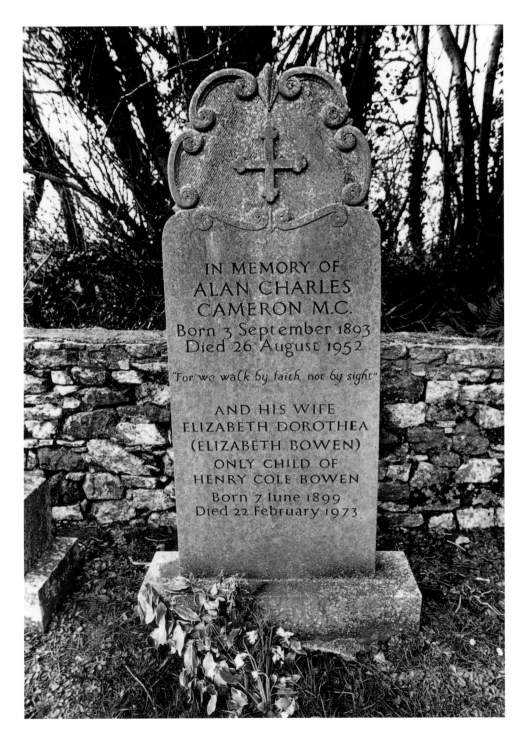

Grave of
Elizabeth Bowen,
novelist and
short-story writer,
Farahy, Co. Cork, 1998.

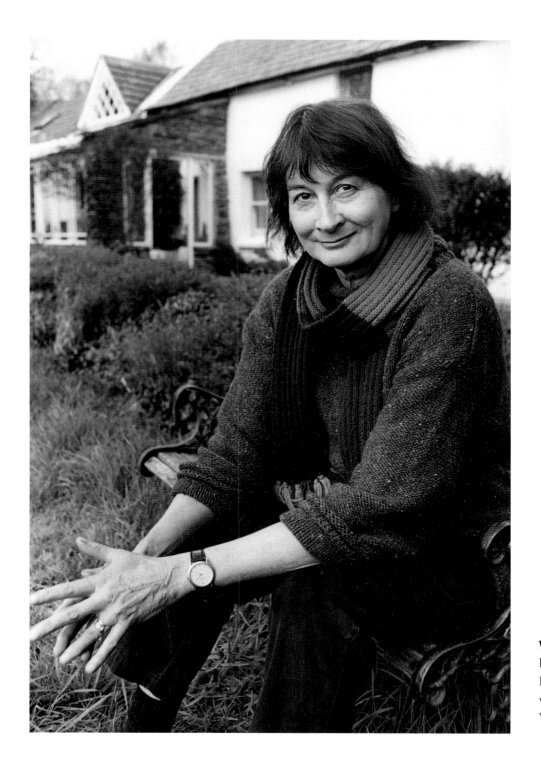

Victoria Glendinning, biographer of Elizabeth Bowen and widow of Terence de Vere White, novelist, Cork 1998.

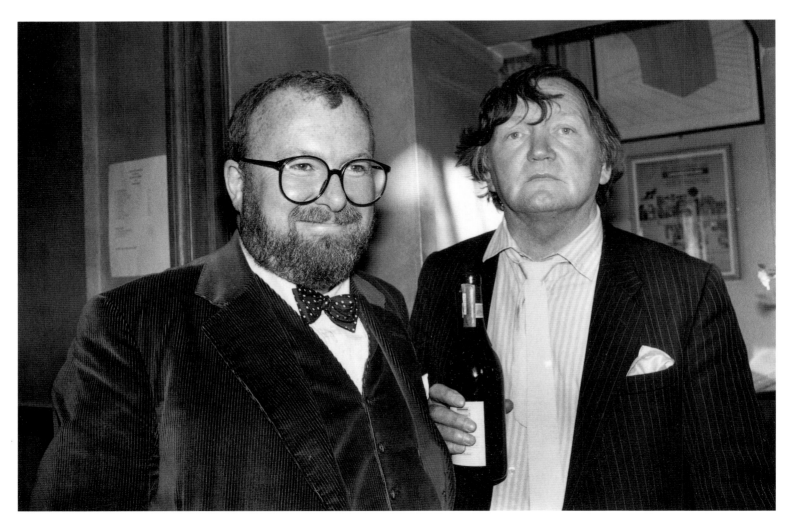

Richard Ryan,
poet and diplomat, and
David MacSweeney,
psychiatrist, London 1982.

Mulligan's Bar,
Dublin 1997.

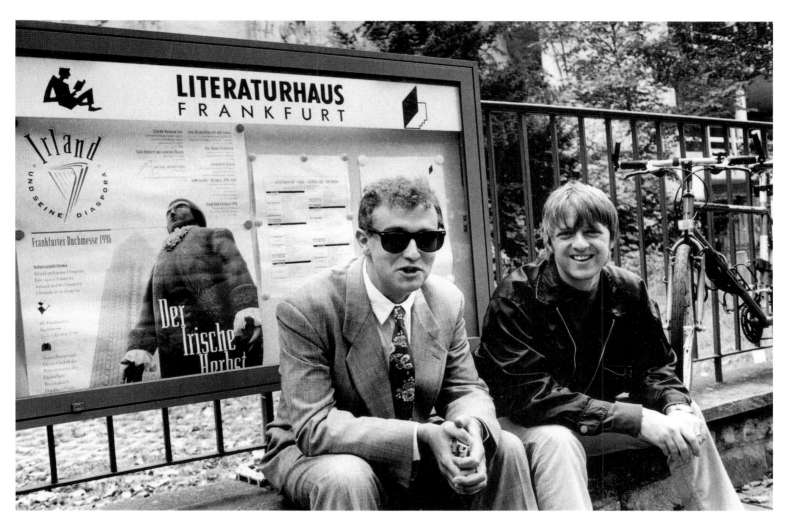

Joseph O'Connor, novelist, and **Glenn Patterson**, novelist, Frankfurt 1996.

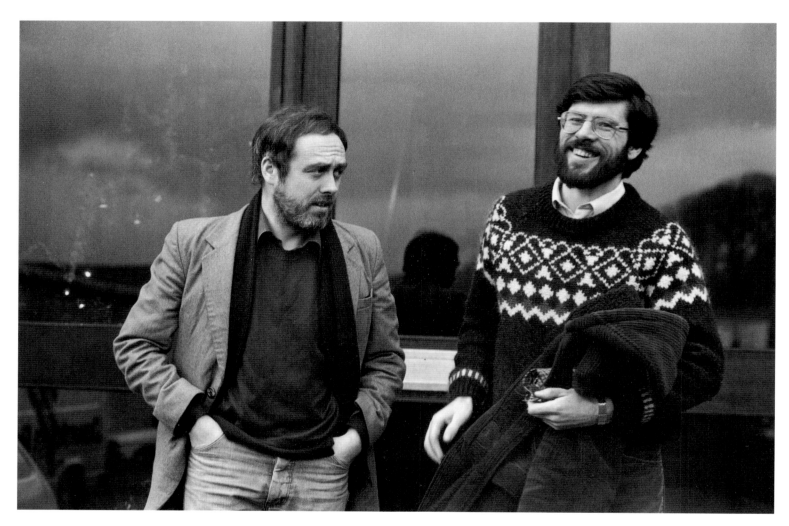

Danny Morrison, writer,
and **Gerry Adams**, writer,
Belfast 1975.

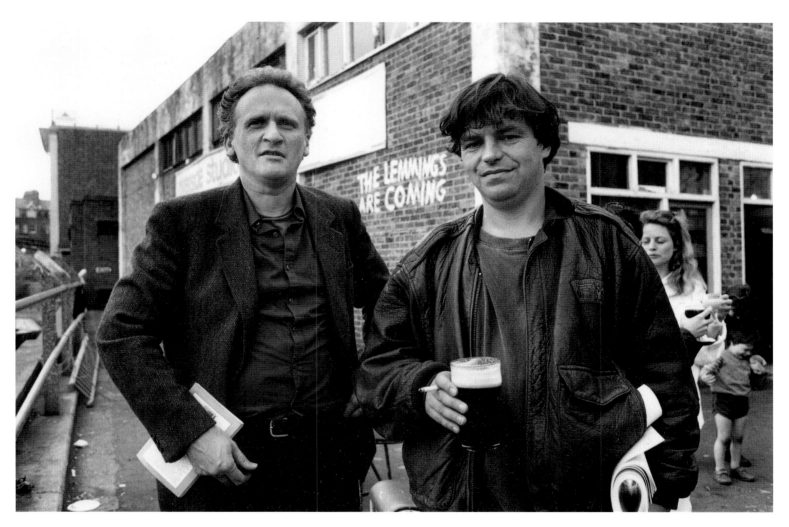

Paul Durcan, poet,
and **Neil Jordan**,
novelist and film director,
London 1987.

Bowe's Bar,
Dublin 1997.

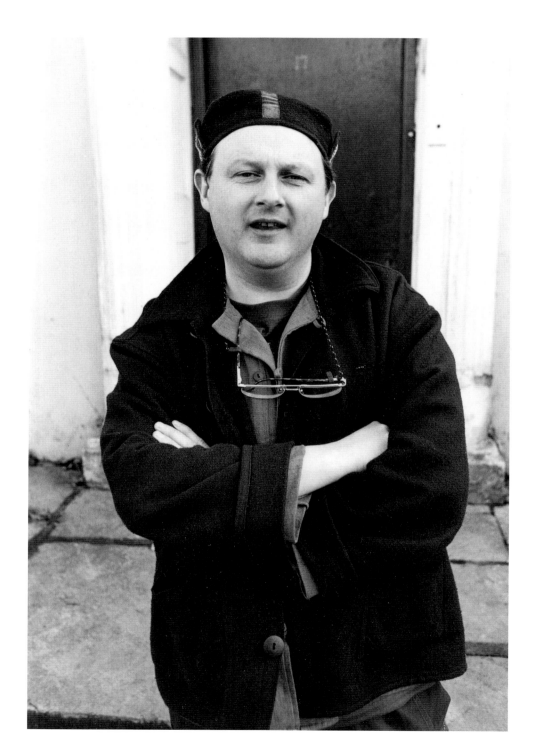

Cathal O'Searcaigh, poet,
Cork 1998.

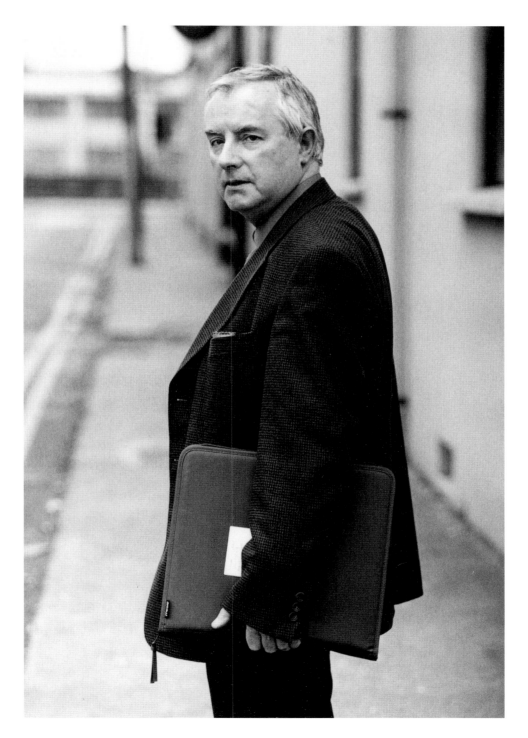

Michael Coady,
poet Cork 1998.

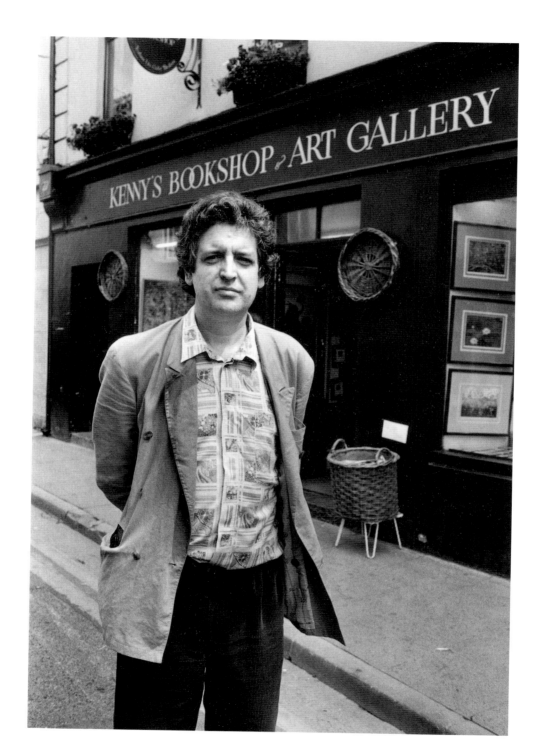

Gerald Dawe, poet,
Galway 1992.

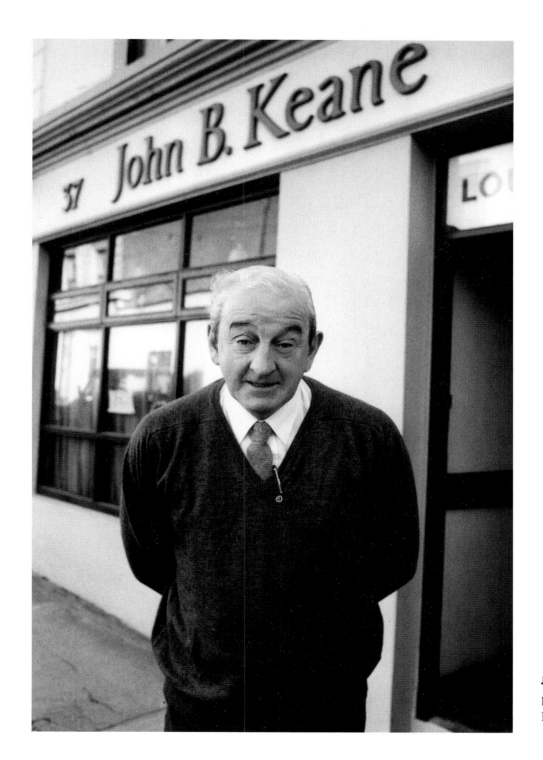

John B. Keane,
playwright,
Listowel, Co. Kerry, 1991.

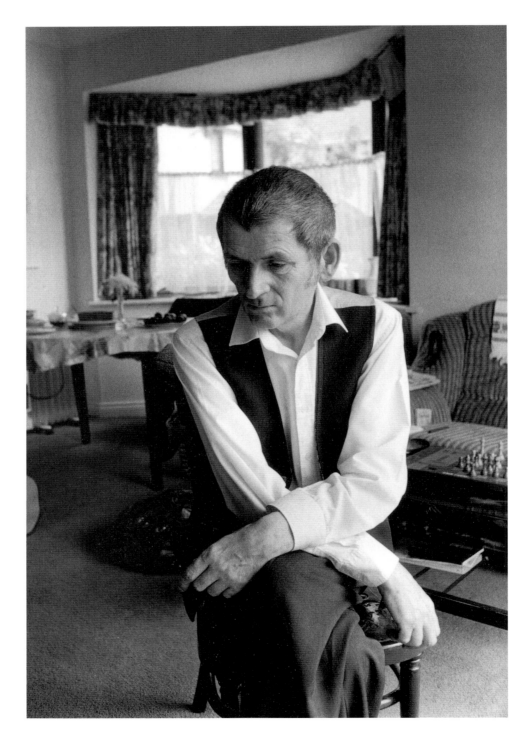

Michael Hartnett, poet,
Dublin 1997.

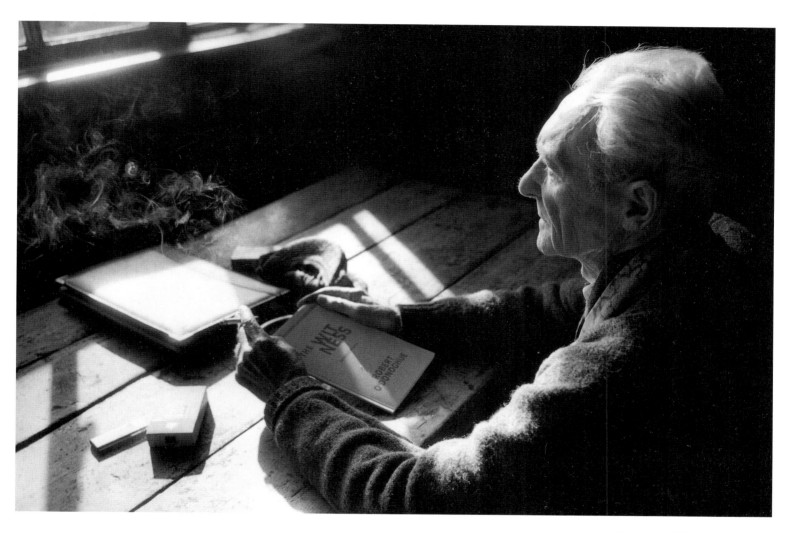

Robert O'Donoghue,
poet and journalist,
Cork 1998.

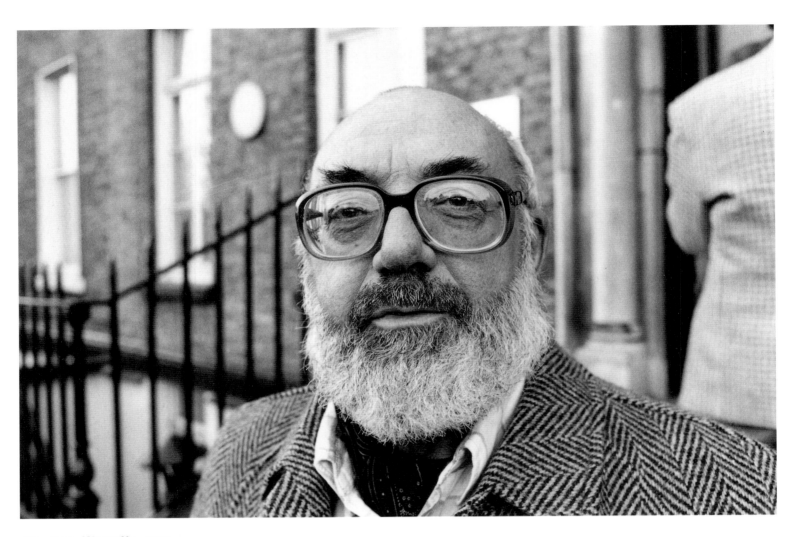

Thomas Kinsella, poet,
Dublin 1984.

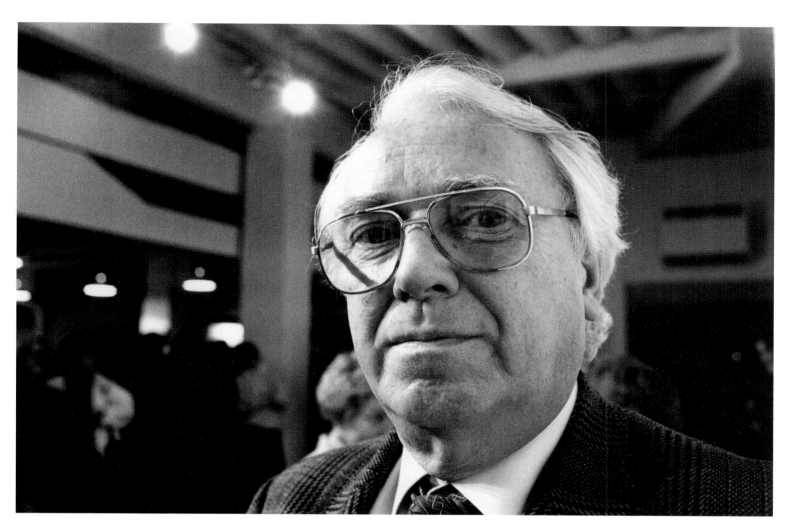

Hugh Leonard,
playwright,
London 1987.

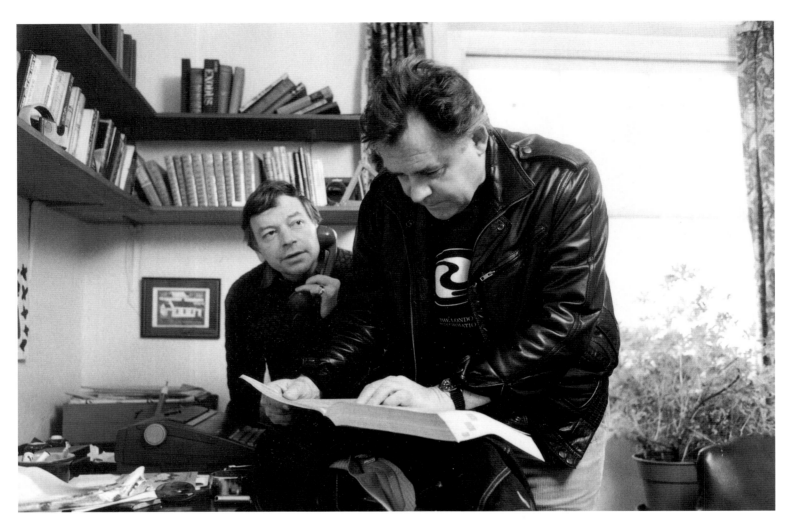

Maurice Leitch, novelist,
and **Ian Cochrane**,
novelist, London 1988.

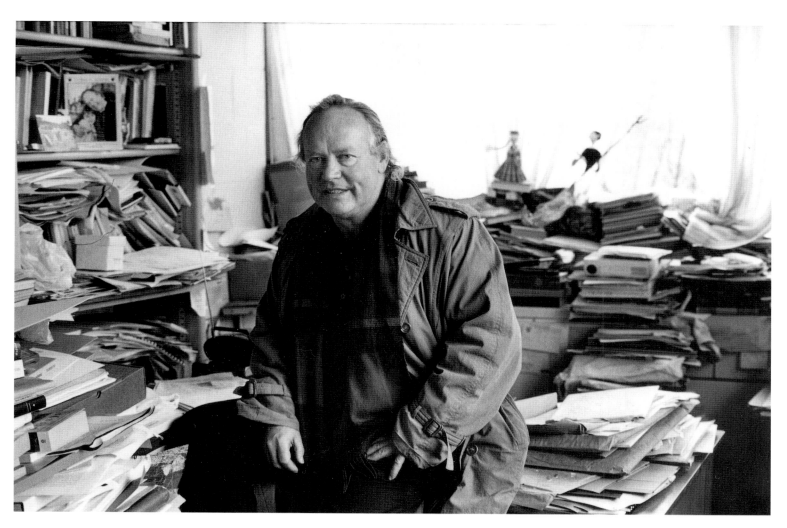

Brendan Kennelly,
poet, novelist and playwright,
Dublin 1997.

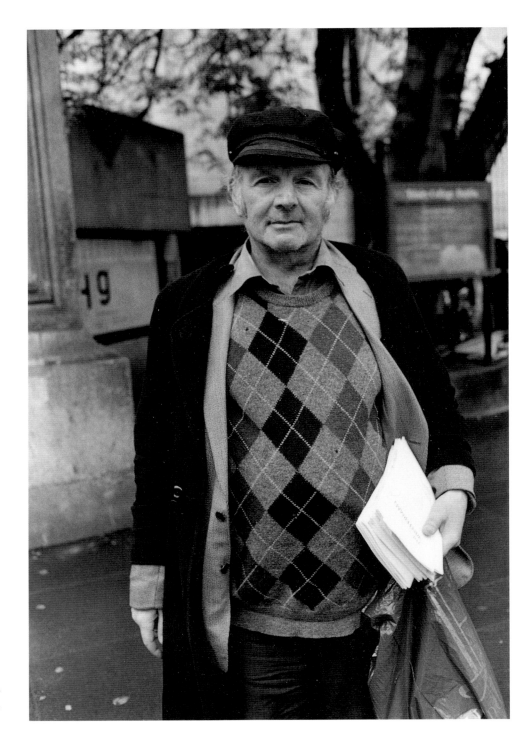

Christopher Daybell, poet,
Dublin 1998.

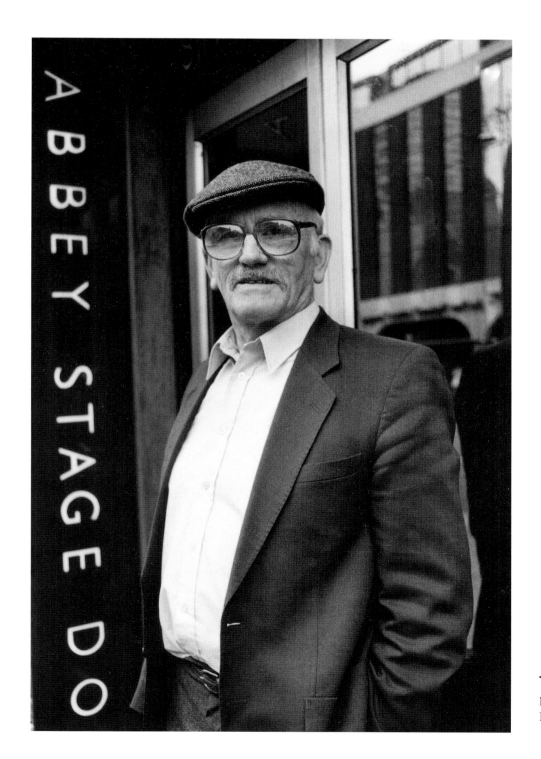

TomKilroy,
playwright and novelist,
Dublin 1994.

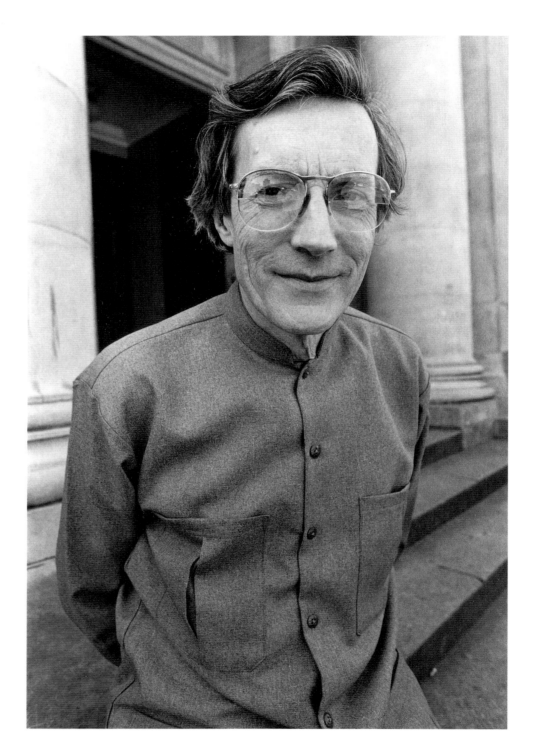

Richard Murphy, poet,
Dublin 1991.

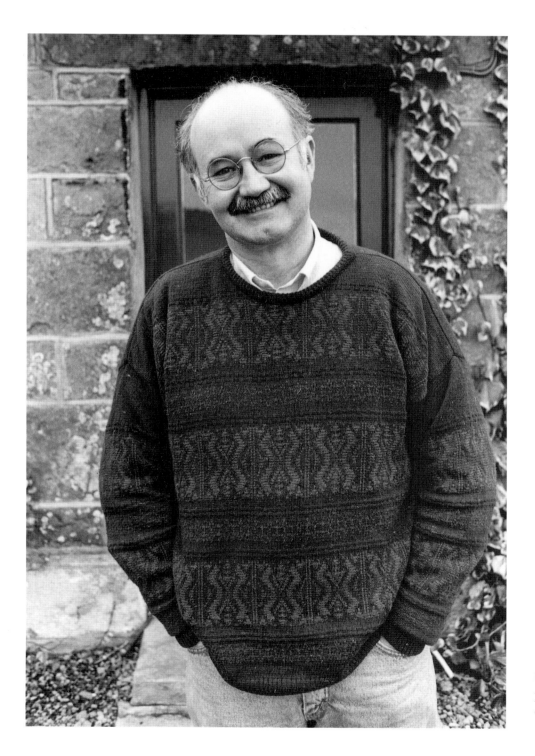

Peter Fallon,
poet and publisher,
Co. Meath 1998.

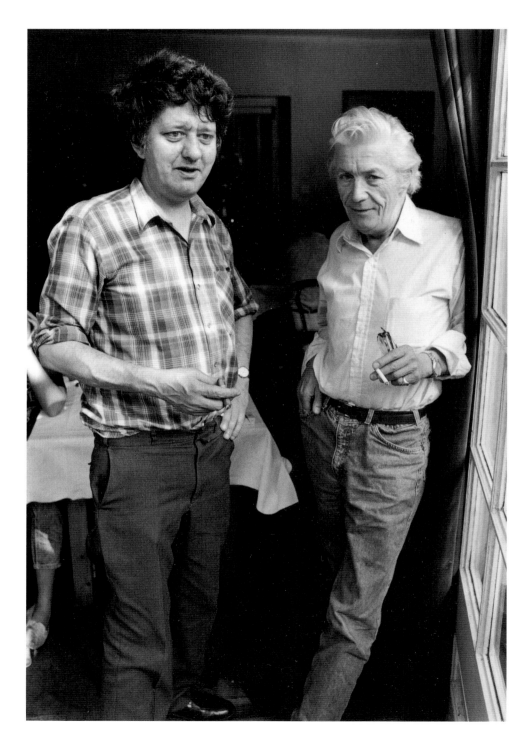

Stan Gébler Davies,
journalist, and
Jeffrey Bernard, journalist,
London 1988.

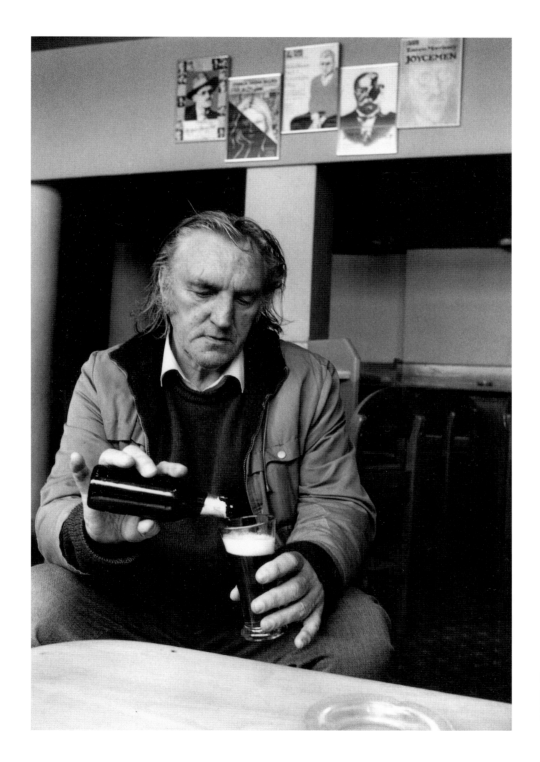

Con Houlihan,
journalist,
Dublin 1983.

107

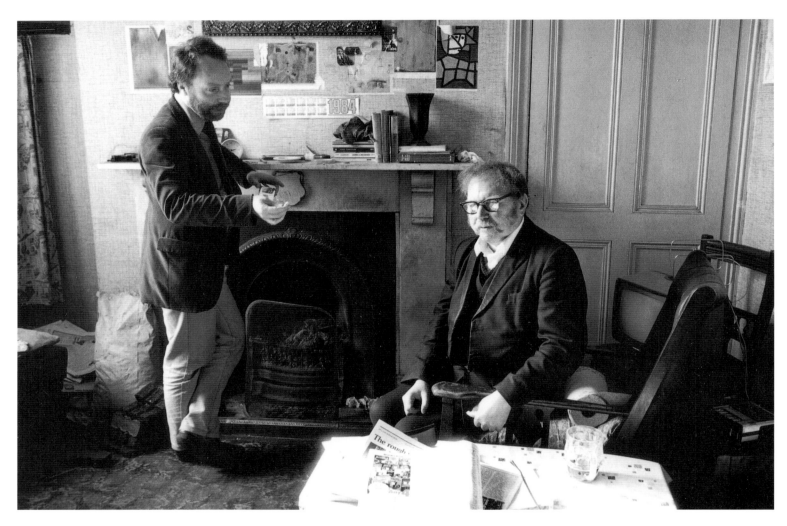

Brian Keenan,
teacher and writer, and
Padraic Fiacc, poet,
Belfast 1984.

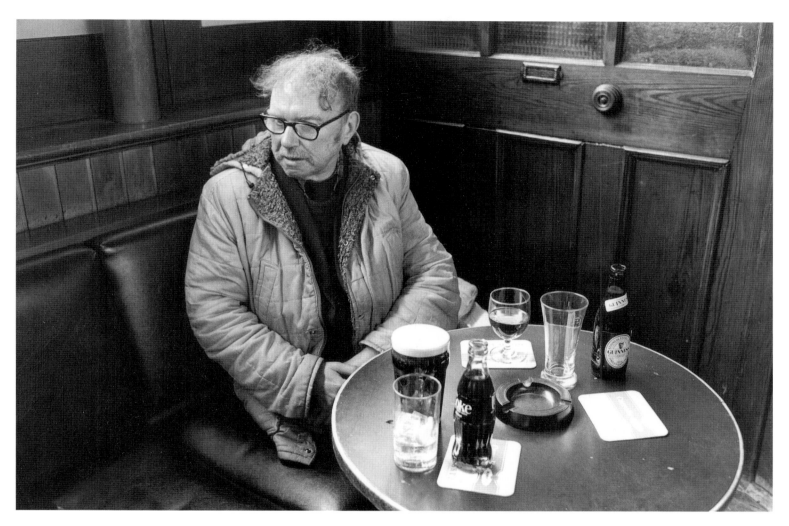

Padraic Fiacc, *poet,*
Dublin 1987.

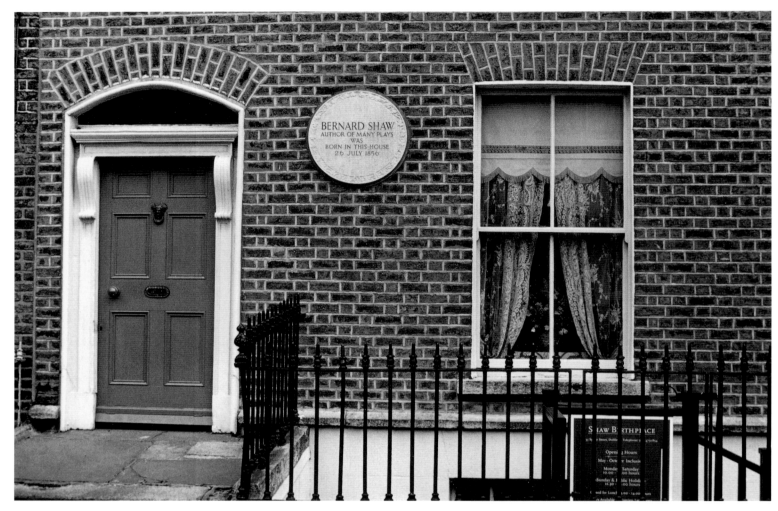

Birthplace of
George Bernard Shaw,
playwright, man of letters
and Nobel Prizewinner,
Dublin 1996.

Birthplace of
Patrick Pearse,
writer and revolutionary,
Dublin 1998.

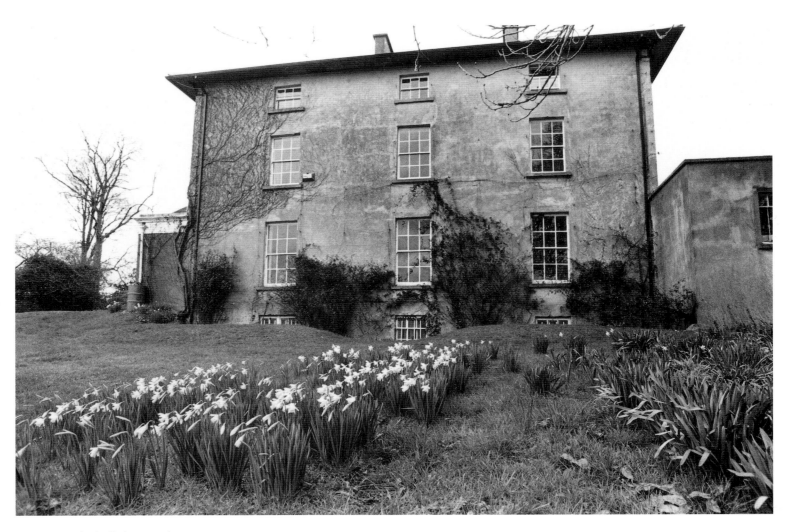

Maidenhall, home of
Hubert Butler, writer,
Kilkenny 1998.

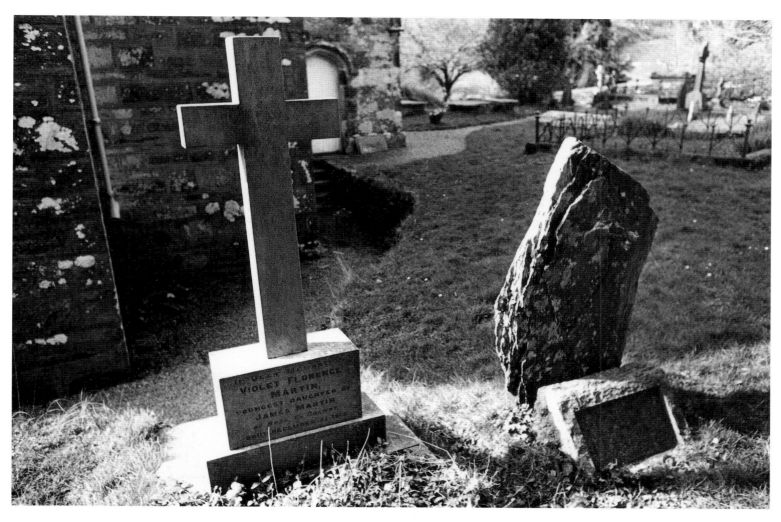

Graves of
Somerville and Ross,
co-novelists, Castletownsend,
Co. Cork, 1998.

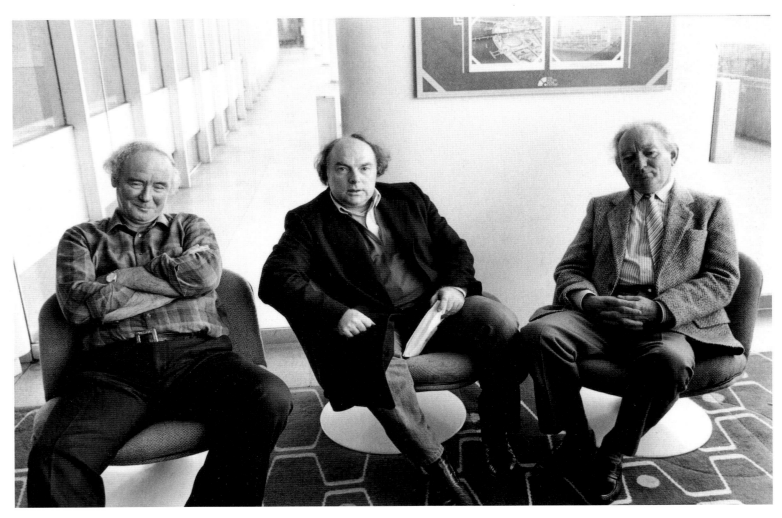

(left to right)
David Hammond, musician;
Van Morrison, musician;
and **Brian Friel**, playwright,
London 1986.

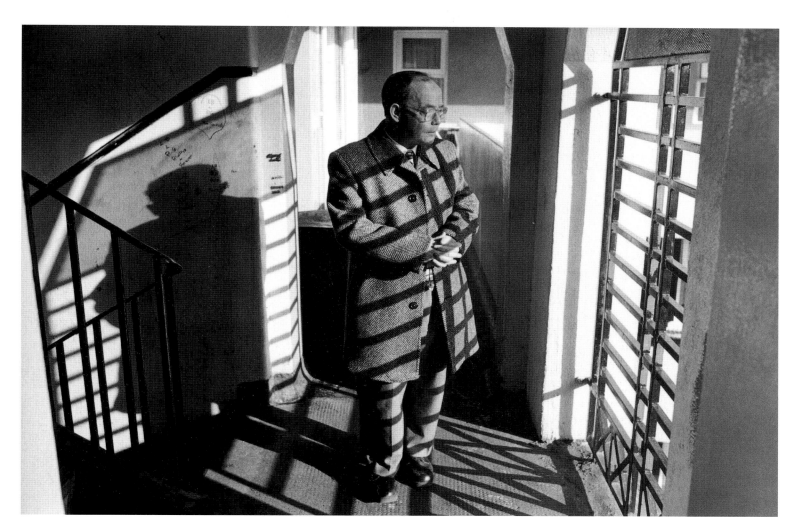

Heno Magee,
playwright,
Dublin 1997.

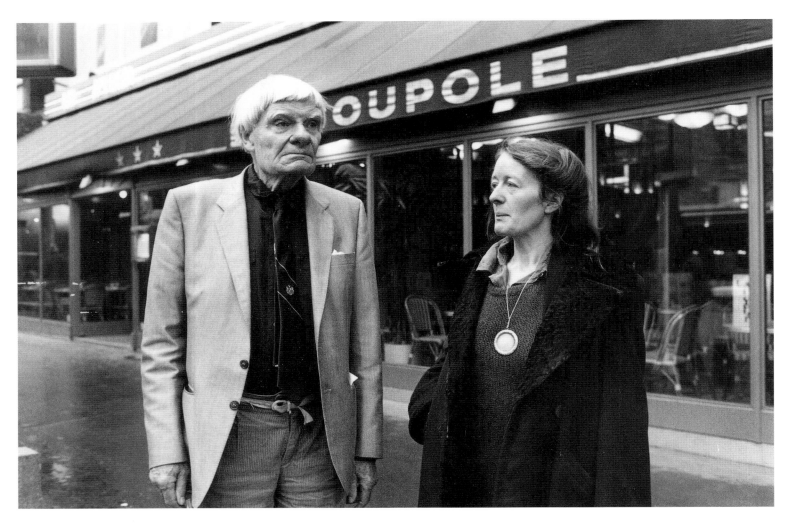

Francis Stuart
(see p.81) and his wife
Finola Graham,
Paris 1989.

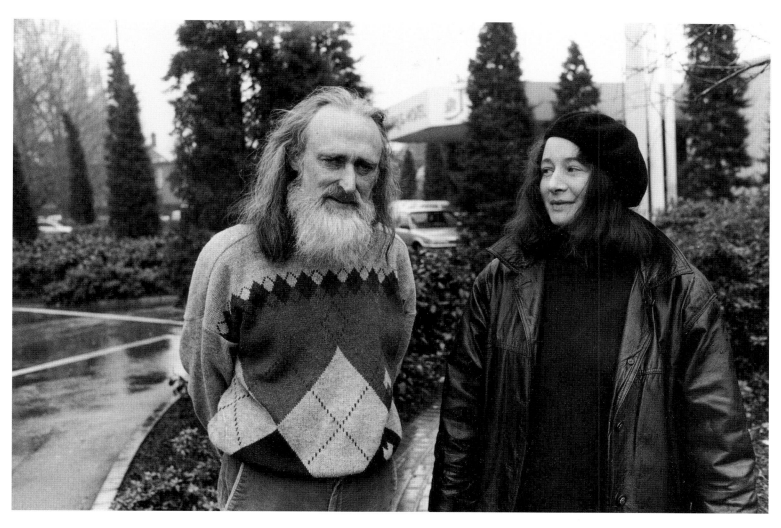

Greg O'Donoghue, poet,
and **Liz O'Donoghue**, poet,
Cork 1998.

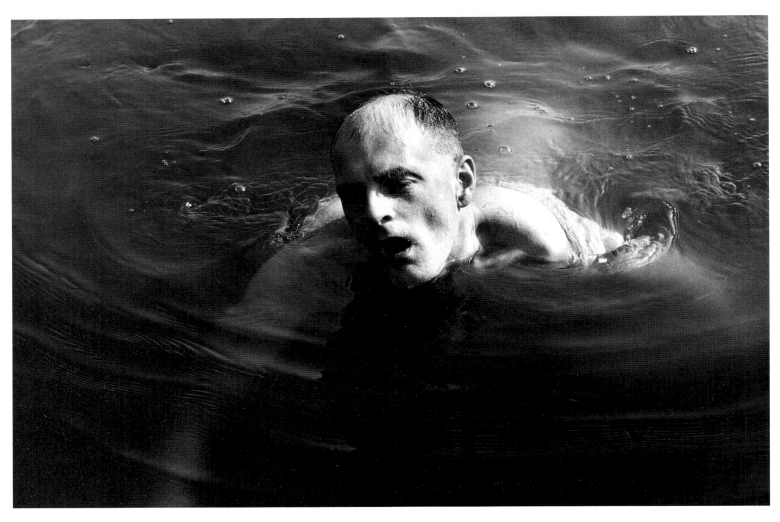

Desmond Hogan,
playwright, novelist
and short-story writer,
London 1991.

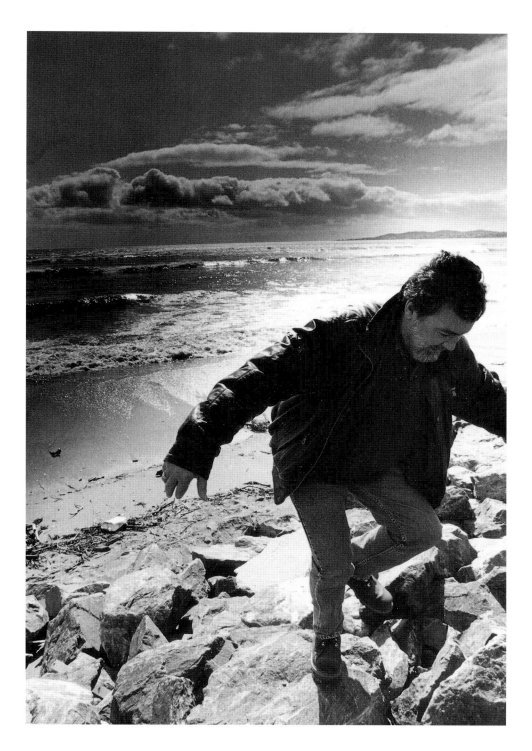

Macdara Woods, poet,
Shelley Banks, Dublin, 1998.

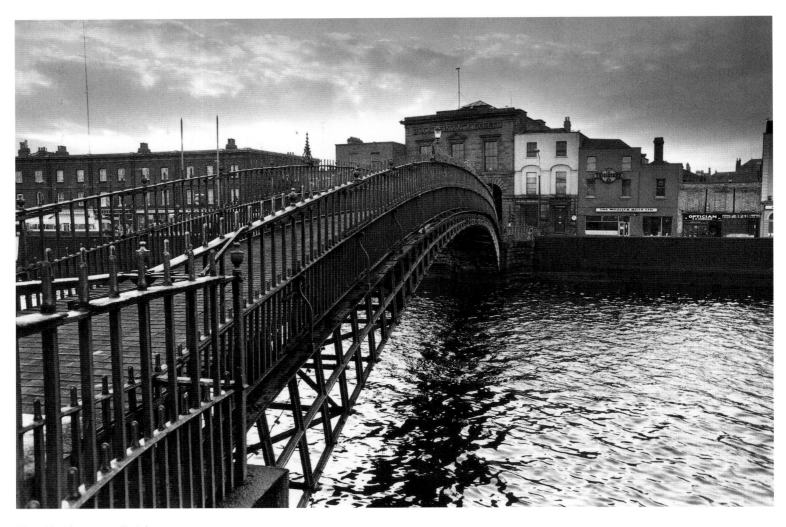

The Halfpenny Bridge,
Dublin 1964.

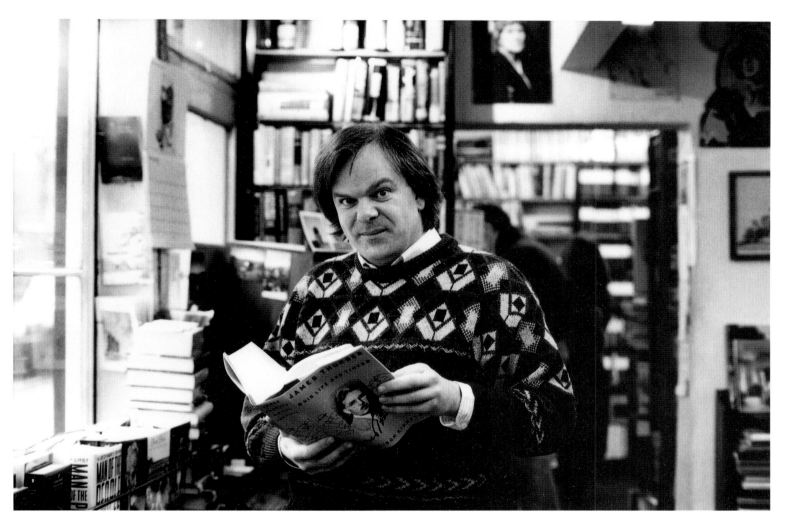

John Wyse Jackson,
writer, publisher
and bookseller,
London 1995.

Shoe shop frontage,
Dublin 1996.

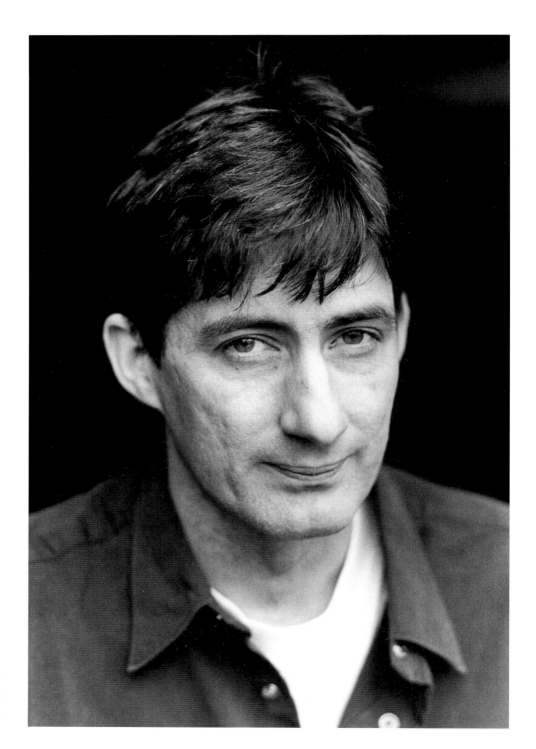

Eoin McNamee,
novelist,
Cork 1998.

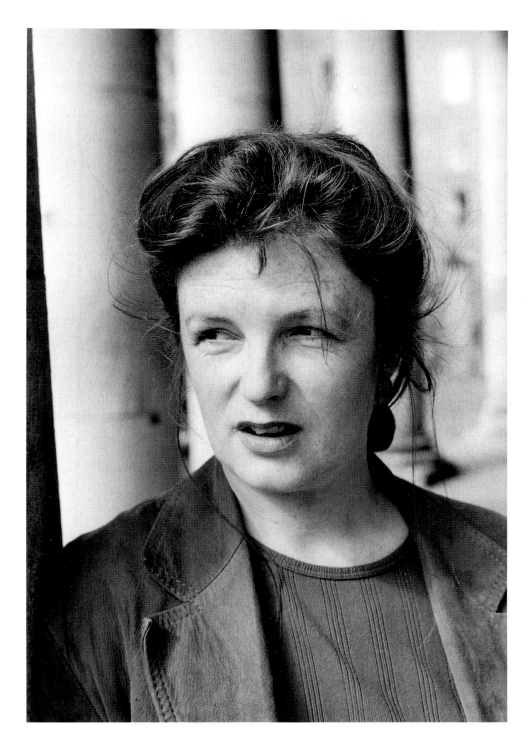

Christine Dwyer-Hickey,
novelist, Dublin 1997.

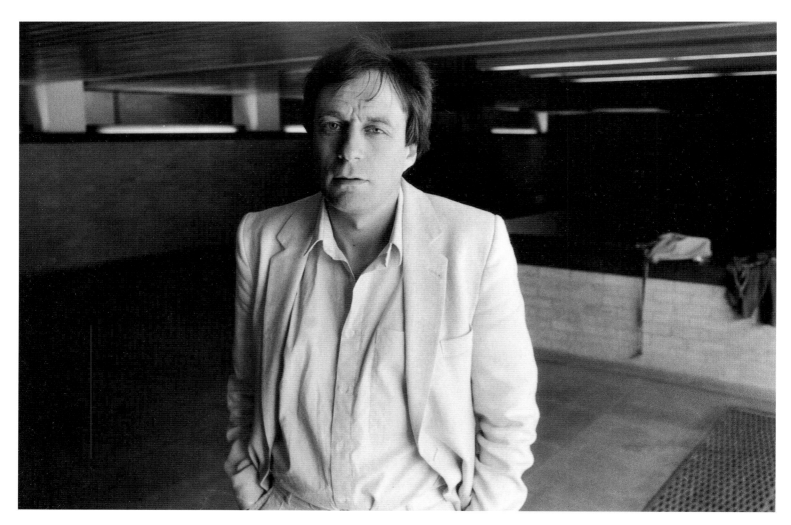

Tom Paulin,
poet and critic,
Oxford 1986.

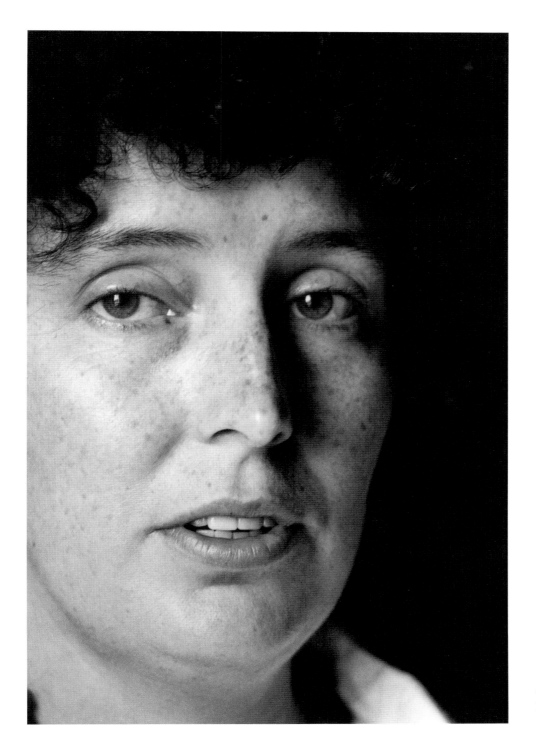

Alannah Hopkin, *novelist,*
Kinsale, Co. Cork, 1986.

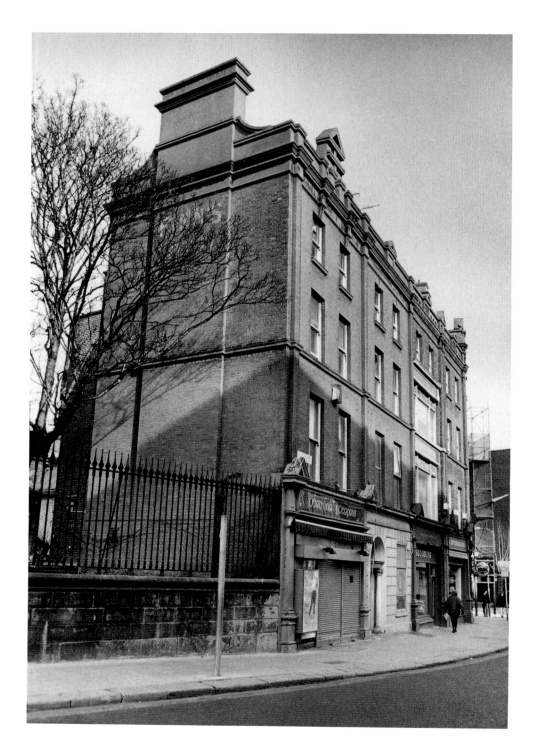

Finn's Hotel,
Dublin 1997.

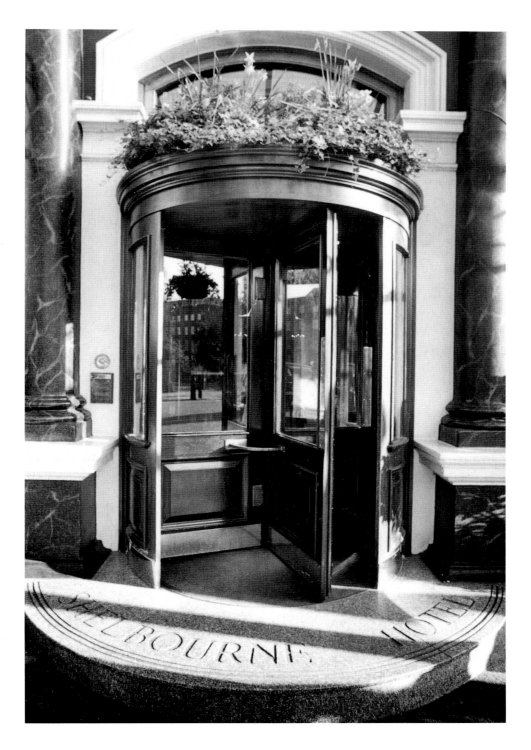

The Shelbourne Hotel,
Dublin 1997.

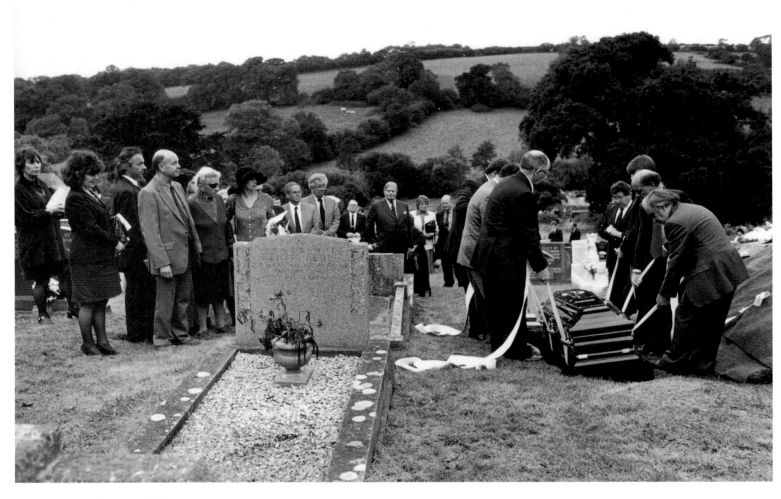

The funeral of
Caitlin Thomas,
née Macnamara,
widow of Dylan Thomas,
Laugharne, Wales, 1994.